THE ART AND BUSINESS OF
Photo Editing
Selecting and Evaluating
Images for Publication

Bob Shepherd

AMHERST MEDIA, INC. ■ BUFFALO, NY

Dedication

This book is dedicated to my mother and father, Florence and Robert Shepherd Sr., for all the love and support they have demonstrated and the wonderful memories they have generated throughout my childhood and into my adulthood. Thanks, Mom and Dad, for those Schwinn™ bicycles you bought for my sister and me during one particular Christmas so many years ago, even under those early economic hardships. Your countless unselfish acts have created beautiful memories that I will cherish all the days of my life!

Published by:
Amherst Media, Inc.
P.O. Box 586
Buffalo, N.Y. 14226
Fax: 716-874-4508
www.AmherstMedia.com

Publisher: Craig Alesse
Senior Editor/Production Manager: Michelle Perkins
Assistant Editor: Barbara A. Lynch-Johnt

ISBN: 1-58428-050-6
Library of Congress Card Catalog Number: 00 135908

Printed in the United States of America.
10 9 8 7 6 5 4 3 2 1

Notice of Disclaimer: The information contained in this book is based on the author's experience and opinions. The author and publisher will not be held liable for the use or misuse of the information in this book.

Table of Contents

The Art of Editing Photographs

● Introduction

Which of the photographs of the train is the better image? Before answering this question, let's begin this lesson with another question: What is meant by the art of editing photographs? Photography is both an art and a science. Before you can put the *art* of photography to work, you must apply the *science* of photography. The science of photography relates to the practical application of the equipment and accessories necessary for shooting photographs: light meters (exposure control), cameras, lenses, tripods, power sources (batteries and power packs), and recording media (film). The science of photogra-

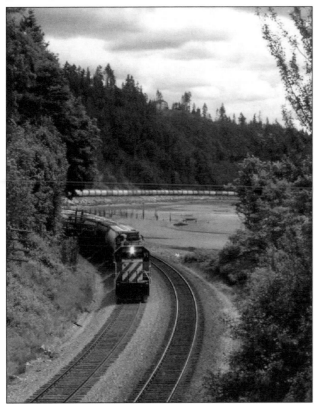

Photograph 1-1

Photograph 1-2

phy is equipment-intensive. The art of photography relates to the creation and manipulation of images for presentation to the viewer. It includes the ability to evaluate, critique, and edit photographs for exhibition or publication. The art of photography is image-intensive.

Why is it that some photographers consistently get their work published in magazines, trade journals, textbooks, and advertisements, while other photographers struggle to get their images barely noticed? Why is it that some photographers consistently get their work exhibited in photo galleries and the art departments of universities, while other photographers receive rejection notices and courteously-worded decline letters?

The art of editing photographs is not unlike editing a manuscript. A good writer will perform a key function before submitting his or her article or manuscript to a publisher—edit, edit, and edit. Unfortunately, good photographers often fail to apply the same principle to their photographs before submitting them to photo editors for publication consideration. Edit a photograph? Some photographers find the idea absurd! How do you edit a photograph like you would a manuscript?

Achieve clarity of subject, logic, and consistency.

Manuscript editing involves the identification and correction of typographical errors, punctuation errors, misspellings, and formatting inconsistencies, as well as grammar checks, word usage, capitalization, word breaks, tone, and format. The conscientious author who seeks a market for his or her work attempts to achieve clarity of subject, logic, and consistency. Confusing and awkward writing is reworked. Sentences are analyzed for structure/syntax. Long sentences may be enumerated or separated, and conflicting statements are clarified and resolved.

The author who wishes to submit his or her work for publication consideration edits the manuscript at least three times, performing a light edit the first time, a medium edit the second time, and a heavy edit the third time. Some writers edit their work half a dozen times or more before submitting their manuscripts for editorial review and evaluation.

During the first or light edit, the author corrects faulty spelling, grammar, and punctuation; ensures the correct usage of words (*can* for *may* or *shall* for *will*); and checks cross-references (for example, *refer to table 6* or *see figure 4*). He or she also ensures consistency in spelling, hyphenation, numerals, fonts, and capitalization, and checks for proper sequencing (alphabetical or numerical order) in lists or table and figure numbers. Because a light edit does not normally involve interventions such as smoothing transitions or changing headings, subheadings, or text to ensure parallel structure, the author performs a medium edit after making all necessary corrections to his

or her manuscript as a result of discovering errors from the initial light edit.

During the second or medium edit, the author makes the necessary changes to headings, subheadings, and text to achieve parallel structure. Inappropriate figures of speech are corrected, and key terms are handled appropriately. Vocabulary lists and indices are thoroughly checked to ensure that they contain all the items that may be specified by a publisher. Previews, summaries, and end-of-chapter questions are examined for proper content, and subject matter is tracked for continuity.

Finally, during the third or heavy edit, the author eliminates wordiness, triteness, and inappropriate jargon from the manuscript, smooths transitions, moves sentences to improve readability, and assigns new levels to headings and subheadings to achieve logical structure.

When the author is absolutely confident that he or she has polished his or her manuscript to near perfection, he or she will submit it for publication consideration. The author has done everything possible to ensure that the publisher receives only the best copy of the manuscript.

Okay, you mutter to yourself, how does all of this relate to editing a photograph? A photograph doesn't contain words, sentences, and paragraphs. Oh, but it does! The words, sentences, and paragraphs don't appear as letters of the alphabet strung together; they appear, instead, as compositional elements, geometrical constructs, and visual cues that send emotional statements to the viewer. If the photographer expects to successfully publish his or her work, he must learn to be as meticulous and consistent in editing photographs as the author is in editing manuscripts.

The identification and correction of typographical errors, punctuation errors, misspellings, and formatting inconsistencies in manuscripts is similar to the identification of a subject or theme and the elimination of confusing or distracting elements in photographs. Likewise, achieving clarity of subject, logic, and consistency in manuscripts is similar to the simplification of a subject or theme and the elimination of visual clutter in a photograph. Similarities abound between editing manuscripts and editing photographs. Reworking confusing and awkward writing in manuscripts is similar to recomposing, cropping, and spotting in photographs. Clarifying and resolving conflicting statements in manuscripts is similar to eliminating or de-emphasizing compositional elements that compete for attention in a photograph. Analyzing sentences for structure and syntax in a manuscript is similar to ensuring that a universal theme is easily recognized and understood in a photograph.

A universal theme is easily recognized and understood in a photograph.

Years of teaching photo criticism for the purpose of selecting and evaluating photographic images for publication have convinced me that one of the best ways for photographers—amateurs and professionals alike—to successfully market their work is to acquire a solid understanding of the art of editing photographs. As a professional photo editor, I can unequivocally state that out of every one hundred photographs that cross my desk for publication purposes, about half a dozen qualify for serious consideration. That's about a 6% success rate. In other words, 94% of all the photographs that photo editors evaluate get rejected!

This book is about learning how to edit photographs for publication. Experience has taught me that most photographers would rather shoot photographs than edit them. There's a good reason for this. Most photographers don't know how to properly edit a photograph for publication purposes. Unfortunately, photographers who don't know what to look for in marketable photographs very seldom get their work published. Published photographers are critics! They *do* know what to look for in a publishable photograph. Photography is an art form and art is subjective, isn't it? This is true! That said, how does one determine what constitutes a publishable photograph?

● Learn to Be a Critic

Imagine for a moment that you've just received a letter from the editor of *Social Issues* magazine in response to your inquiry about your collection of transparencies depicting poverty. The September issue of the magazine is going to feature a photo essay about the plight of people trapped in poverty. The editor would like you to submit a half dozen of your best images for evaluation and consideration. Based on the quality and impact value of the images submitted, the editor may ask you to submit additional images for publication. The magazine needs ten images for use in the photo essay, and one blockbuster image for the magazine's cover page. This is it! This is the golden opportunity you've been working toward. Finally, after shooting hundreds of photographs and expending as many hours trying to capture emotionally arresting images, your moment of fame may have arrived. What do you do?

You climb Mount Everest, that's all! Okay, I'm kidding, really. But you do have one daunting obstacle to face! The publisher expects you to edit and select the most compelling images for the story—images that will evoke nothing less than deep emotional responses from all who see the photographs. Don't count on that fame yet. Your most important task is at hand.

The editor for the publishing company knows what to look for in images that will move the viewer. He or she knows what questions to

This is the golden opportunity you've been working toward.

8

ask during the evaluation process. Remember, photography is an art form, and art is subjective. There are, however, established criteria by which a photo editor can evaluate and select really outstanding photographs from a stack of good photographs. It's your job to ensure that every image you submit to an editor meets these criteria.

If you know the theme is poverty, your first job is to observe your images with a discerning eye for strong visual cues that cry out destitution, hopelessness, and despair. You should ask yourself:

- Which images successfully and forcibly illustrate the theme?
- Will the images move the viewer emotionally?

After you have selected a few dozen images that satisfy these questions, your second job begins. You meticulously arrange the images in an orderly sequence on a light box. Having a bright source of light is crucial to your examination process. As you examine the first image, ask yourself a myriad of questions:

- Is the theme easily identifiable?
- Does the image have visual impact?
- What is the main subject?
- Is the main subject emphasized?
- Has the image been simplified?
- How are the composition and balance?
- Is the photograph properly exposed? (Here is where a good magnification loupe will prove to be extremely advantageous. Evidence of camera shake, poor focusing, and fuzzy lines around objects are easily detected with a loupe.)
- If the image is in color, are the colors rich and saturated?
- If the image is black and white, is the contrast and exposure correct?
- Is there a good range of gray tones?
- Does the image evoke an emotional response?
- Is the response to the image positive or negative?
- What subject emphasis techniques, such as framing, selective focus, converging lines, repetition, motion, placement of the main subject, etc., have been employed to enhance the image?
- Does the image contain a universal theme?

After you've asked—and answered—these questions, the same questions must be reapplied to each photographic image, until you have finally selected the six best images for submission to the editor.

Does the image have visual impact?

But do you really understand the difference between a subject and a theme? What is visual impact? What do subject emphasis and simplification mean? How do you determine if a photograph is compositionally balanced and properly exposed? Or if the contrast and exposure in a black and white photograph are correct? What is a good range of gray tones? What is a universal theme?

Only when you answer these questions and determine whether your photographic images meet these requirements can you be reasonably sure that the images you submit to an editor will be received with favor.

● The Purpose of This Book

This book is about understanding and applying the concepts of patterns, balance, and order; the principle of thirds; colors, tones, and exposure; subject emphasis; the Zone System; universal themes and other elements that go into identifying publishable photographs.

Millions of photographic images are purchased every year by publishing houses, photo marketing companies, stock photo agencies, and other visual-impact businesses whose monthly acquisition budgets are as much as $100,000 or more. Some publishing and photo marketing giants spend millions of dollars on the acquisition of photographic images. In the past few decades, there has been a phenomenal explosion in the use of photographs in education, science, entertainment, advertising, magazines, textbooks, and other visual media. We live in an information society, and most of the information we receive is visual. We are constantly being bombarded by images day in and day out. Because of this, we have developed a defense system to prevent our brains from becoming overloaded. We take in literally thousands of images every day, but very few of those images actually command our attention.

Those few images that command our attention do so because of their grabbing power—their impact upon our emotions! Advertising agencies are well aware of the emotional messages certain images project. Photographers who know which images will tug at our emotions, and are capable of discerning the differences between good photographs and truly outstanding photographs, are light-years ahead of their competitors when it comes to the publication of their images.

● What You Will Learn in This Book

This book is divided into five lessons and two appendices. Appendix A contains the answers to the section self-tests found in lessons 2 through 5. Appendix B contains a list of helpful resources that you can use for marketing your photographic images.

> Images that command our attention do so because of their grabbing power.

Lesson 2, "Patterns, Balance, and Order," demonstrates why the concepts of patterns, balance, and order are important to understanding what constitutes an outstanding photographic image. This lesson begins with a discussion on the Golden Rectangle and how it is related to nature, art, and photography. After completing this lesson, you will understand and fully appreciate why 35mm film frames were designed to approximate the Golden Rectangle. Other topics in this lesson include:

- The principle of thirds and how it affects the overall balance and order of a photographic image
- How themes and subjects are emphasized through:
 Selective focusing
 Placement and composition
 Converging lines
 Repetition and/or framing
 Visual layering and other techniques
- How geometric forms create patterns, and why they attract the mind's eye
- How inanimate objects communicate with each other in a photo and how they communicate with the viewer
- Photographic examples of how the concepts of patterns, balance, and order are applied within each of the photographic frames

In lesson 3, "Colors, Tones, and Exposure," you will learn about color saturation and color balance, fidelity and contrast, the importance of color tones in black and white photographs, gray tones, the Zone System, and how to properly use a gray scale. You will learn to distinguish between soft focus, selective focus, out of focus images, poorly focused images, and camera shake. Most importantly, you will learn how to identify properly exposed photographs. You will learn how to use the photo editor's magnification loupe to examine photographs for image sharpness and proper exposure. You will also learn how to use the Zone System gray scale for evaluating black and white photographic images, and the color wheel for working with color photographs. The photographs in this lesson demonstrate how the concepts of colors, tones, and exposure are applied in each of the photographic frames.

In lesson 4, "The Perfect Photograph," you will learn which qualities go into the perfect photograph; the characteristics of good black and white prints; the characteristics of good color prints; the importance of universal themes; what to look for in negatives and transparencies; the difference between commercial and custom pro-

35mm film frames were designed to approximate the Golden Rectangle.

Maintain aspect ratio when reducing or enlarging photographs.

cessing; the pros and cons of Cibachrome and internegative reproductions; how to effectively crop photographs for visual impact and to repair minor blemishes through a technique called spotting. The photographic images provided in this lesson will clearly illustrate how all of the qualities and elements that go into creating perfect photographs are applied within each of the photographic frames.

The first four lessons will provide the basic foundation for lesson 5, "Editing Photographs for Publication." In this lesson, you will be guided through the many steps of evaluating and editing a photograph for publication. Most importantly, you will learn to target the audience that will be most receptive to the kind of photographs you wish to market. In the last section of this lesson, you will learn the five most important criteria for selecting and editing marketable photographs for publication purposes, and how to apply each of these criteria to your own images. The photographs provided in this lesson will illustrate the evaluation and editing processes, as well as how to transform a good image into an outstanding image. This lesson begins with a photograph in landscape format; we will evaluate it, edit it, and crop it for visual impact, ending up with a better image in portrait format. Finally, you will learn how to maintain aspect ratio when reducing or enlarging photographs, and why maintaining aspect ratio is important in the publishing and photo-marketing industry.

● How to Study the Material in This Book

This book is divided into lessons. Beginning with lesson 2, "Patterns, Balance, and Order," the text is divided into learning compartments called sections. Each section is broken down into subsections. Sections or blocks of learning material that have been broken down into bite-sized subsections have repeatedly proven to be easier to read and comprehend.

Throughout the text, questions are used to reinforce your understanding of the preceding materials. The answers to these questions appear within the text. Use an index card to cover the answers as you read the questions, then uncover that area to check the accuracy of your answer(s). If you answer any of the questions incorrectly, be sure to read the preceding subsection again to ensure that you fully comprehend the information before continuing on to the next section or subsection.

Programmed Instruction. This method of reading a certain amount of text accompanied by questions and answers is generally referred to as programmed instruction. Programmed instruction has been shown, through extensive psychological research, to be effective in helping the reader retain more information.

Section Self-Tests. Each section ends with a section self-test. The section self-tests will help you evaluate your mastery of the information and concepts presented. Before continuing on to the next section, be sure to complete the section self-test. Answers to the section self-tests are located in appendix A.

● Which Is the Better Photo?

Return to the photographs of the train on page 5. This lesson began with a question: Which of the photographs of the train is the better image? The answer is, it depends on what the photograph is being used for. The area around the train in photograph 1-1 has been cropped, and the image of the train enlarged, resulting in photograph 1-2. Both images satisfy the principle of thirds and other compositional elements that you will learn about in lesson 2, "Patterns, Balance, and Order." However, the subject of each photograph is arguably different. Although there is a train in photograph 1-1, the subject is the entire scene. The size of the train is insignificant when compared to the other compositional elements that comprise the overall image: forest wilderness, dramatic cloud formations, and undisturbed lake—the majestic beauty of nature. In photograph 1-2, the train has been emphasized through placement (a subject-emphasis technique that's explained later in this book). The train fills most of the photographic frame and practically leaps out at the viewer, and the natural setting around the train has been de-emphasized.

Photograph 1-1 would be more suitably used for exhibition, photo art, publication in general consumer and travel magazines, or for advertising purposes (the large open areas around the train permit the inclusion of advertising copy). Photograph 1-2 would be more suitably used for publication in special-interest magazines, like *Trains* or *Model Railroading*, or sold as poster art to train or railroading enthusiasts. This brings us to the very first rule of successful photo editing: Select and edit your images for your target audience. Targeting your audience is discussed in detail in lesson 5, "Editing Photographs for Publication."

Now that you have been introduced to the art of editing photographs, it's time to turn to lesson 2, "Patterns, Balance, and Order," and to begin learning how to apply the art of editing photographs to the selection and evaluation of images for publication.

Select and edit your images for your target audience.

You may qualify for college credit just by reading this book! Contact the International Photo College admissions office at (925) 691-6833, e-mail us at admissions@photocollege.com, or visit our web site at www.photocollege.com for more information.

Patterns, Balance, and Order

● Introduction

This lesson demonstrates why the concepts of patterns, balance, and order are important to understanding what constitutes an outstanding photographic image. This lesson begins with a discussion on the Golden Rectangle and how it is related to nature, art, and photography. After completing this lesson, you will understand and fully appreciate why 35mm film frames were designed to approximate the Golden Rectangle. Other topics in this lesson include:

- The principle of thirds and how it affects the overall balance and order of a photographic image
- How themes and subjects are emphasized through:
 Selective focusing
 Placement and composition
 Converging lines
 Repetition and/or framing
 Visual layering and other techniques
- How geometric forms create patterns, and why they attract the mind's eye
- How inanimate objects communicate with each other in a photo and how they communicate with the viewer
- How the concepts of patterns, balance, and order are applied within photographic frames

The human brain is attracted to orderly and meaningful patterns.

● The Importance of Patterns

The human brain is attracted to orderly and meaningful patterns. Where there are no recognizable patterns, interpretation is impossible. The brain—through the eyes—records visual stimuli, such as shapes, outlines, colors, depth, highlights, and shadows. All these visual inputs are then interpreted as something identifiable: a tree, a mountain scene, a wild animal.

When images are not easily recognizable, as in abstract art forms, the brain still satisfies itself by identifying orderly patterns: rectangles, circles, triangles, curves, lines, etc. Look up into the clouds and your brain perceives all sorts of shapes and figures; stare at an ink spot and, eventually, images of faces, animals, and flowers spring into mind. Almost everyone can see the man in the moon. The brain refuses to accept total randomness. If there is no pattern to be found, the brain will not be satisfied, and the observer will react indifferently to the image being observed. Some people are attracted to abstract forms because their brains detect a pattern. The observer may not be conscious of the pattern, but the observer's brain will sense its presence.

A Good Photograph Contains Recognizable Patterns. As someone who wants to become proficient in editing photographs, you must develop the ability to recognize successful images. Successful images contain recognizable patterns. You must ensure that some kind of order has been imposed on the objects within the frame of every photograph you edit. Even though there are no real rules that a photographer must abide by, there are established criteria by which really good photographs can be distinguished from mere snapshots. These criteria have been established through extensive psychological testing and careful evaluation, and through attempts to answer questions like: How does the brain receive visual inputs? Why do certain types of visual inputs stimulate the brain, while others dissatisfy it?

Research has established that the brain readily accepts visual images that contain identifiable patterns, where these patterns are composed in an orderly manner within a well-defined frame. What type of frame gives the most stimulation to the brain? You guessed it: a Golden Rectangle. A Golden Rectangle may either be in the landscape (horizontal) format or in the portrait (vertical) format. A Golden Rectangle exists whenever a 5:8 ratio is maintained between the sides of the rectangle.

1. **True or False.**
 The brain requires recognizable patterns to interpret visual inputs.

 Answer
 1. True

2. **True or False.**
 The brain will accept total randomness if no patterns are found in an abstract image.
3. **True or False.**
 The brain always makes the observer conscious of an identifiable pattern.

 Answers
 2. False. The brain refuses to accept total randomness.
 3. False. The brain may sense a pattern, but the observer may not be consciously aware of it.

4. You must ensure that some kind of _____ has been imposed on the objects within the frame of every _____ you edit.

 Answer
 4. order, photograph

● The Golden Rectangle

The geometrical construction of a Golden Rectangle (see figure 2-1) begins with a square. A drawing compass is positioned at the center point of the base of the square and extended to the upper left corner.

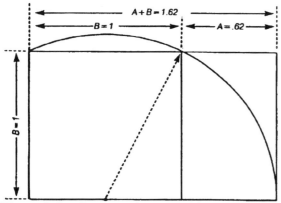

Figure 2-1—Construction of Golden Rectangle *Figure 2-2—Golden Rectangle (5:8 ratio)*

Then an arc is drawn from the upper left corner past the upper right corner and down to a horizontal plane extended from the lower right corner of the square. The intersection of the arc and the extended plane marks the new section, which is added to the square to form a Golden Rectangle. However, this is not a lesson in geometry, so the mathematical formula for constructing a Golden Rectangle is not necessary, nor are you required to learn it. It has been provided here for your general information.

It is enough to know that a Golden Rectangle is a rectangle that is divided into equal segments. The smaller side is divided into five segments and the longer side is divided into eight segments (5:8 ratio). Simply stated, a Golden Rectangle (at a 5:8 ratio) contains forty identical squares within its perimeter. It is five squares wide in one direction and eight squares wide in the other direction. (See figure 2-2.)

> **5. True or False.**
>
> The Golden Rectangle is any rectangle whose length is greater than its width.
>
> *Answer*
>
> 5. False. The Golden Rectangle is constructed to a specific mathematical ratio.

> 6. A Golden Rectangle is divided into _____ identical squares, _____ squares wide in one direction and _____ squares wide in the other direction.
>
> *Answer*
>
> 6. forty, five, eight; or forty, eight, five (both answers are correct)

Mathematically, 5:8 (or 5/8) equals 0.625 (derived by dividing 8 into 5). The ratio of a 35mm film frame is 2:3, and can be expressed as 0.666. . . . Notice how the proportions of the 35mm film frame closely approximate the proportions of the Golden Rectangle (see figure 2-3). Actually, the 35mm film frame (0.666) is slightly larger than the Golden Rectangle (0.625). The slight difference in ratio, however, is visually insignificant and nearly impossible to discern with the eye. At first thought, designing 35mm camera viewfinders—and

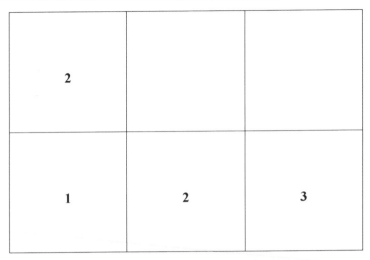

Figure 2-3—35mm film frame (2:3 ratio)

film frames—to the proportions of a Golden Rectangle might not seem to be a great accomplishment. But, when you consider the psychological implications behind the reasoning, as you will soon learn, it makes you wonder about the phenomenal success of 35mm photography.

7. **True or False.** The proportions of the 35mm film frame closely approximate the proportions of the Golden Rectangle.
8. **True or False.** The 35mm film frame is slightly smaller than the Golden Rectangle.

Answers
7. True. The ratio of the Golden Rectangle can be expressed as 5:8 or 0.625 and the ratio of a 35mm film frame can be expressed as 2:3 or 0.666.
8. False. The 35mm film frame is slightly larger than the Golden Rectangle.

The Golden Rectangle in Nature. Why is the brain stimulated by the Golden Rectangle? Because it is widely reflected in the natural world. Flowers, leaves, snails, trees, butterflies, seashells—those things that have been created by nature—all fit nicely into the geometrical form of a Golden Rectangle. Why? Because in nature, things are normally wider than they are tall, or taller than they are wide (see figures 2-4, 2-5, and 2-6). It just happens that these taller than wide or wider than tall dimensions are found more often in a 5:8 ratio—the mathematical ratio of a Golden Rectangle.

It was the ancient Greeks who first made extensive use of the Golden Rectangle. Historians tell us that the Greeks were not aware of the Golden Rectangle's widespread occurrence in nature.

The ancient Greeks first made extensive use of the Golden Rectangle.

Figure 2-4

Figure 2-5

Figure 2-6

Figures 2-4 and 2-5—Golden Rectangle in landscape format

Figure 2-6—Golden Rectangle in portrait format

They applied it to the design and construction of their buildings, and used it in their art, however, simply because they found it pleasing to the eye. Thousands of years later, the same shape is still being used by contemporary artists, architects, and photographers (the 8" x 12" and 11" x 16" full-frame print format developed from 35mm negatives closely approximates the proportions of a Golden Rectangle). The important point to appreciate here is that the brain has been, still is, and probably always will be stimulated by the pleasing proportions of a Golden Rectangle. In fact, because the proportions of the Golden Rectangle are so universally recognized by people of all cultural backgrounds, the Japanese very wisely designed the viewfinders of their 35mm cameras to the same proportions.

9. A Golden Rectangle may either be in a horizontal format, also called _____ format, or in a vertical format, also called _____ format.

10. Why is the brain stimulated by the Golden Rectangle?

11. **True or False.** Standard 8" x 10" and 11" x 14" enlargements from 35mm negatives closely approximate the ratio of the Golden Rectangle.

Answers

9. landscape, portrait

10. Because it is widely reflected in the natural world.

11. False. Full-frame 8" x 12" and 11" x 16" enlargements closely approximate the ratio of the Golden Rectangle. Standard 8" x 10" and 11" x 14" enlargements are not full-frame 35mm prints.

● Section Self-Test #1

Use a separate sheet of paper to write down your responses to the following questions. Check your responses against the answers provided in appendix A.

1. A Golden Rectangle is a rectangle whose proportions are always constructed to a 5:8 ratio. Which of the following dimensions represent a Golden Rectangle?
 a. 5" x 8"
 b. 6" x 9"
 c. 8" x 10"
 d. 10" x 16"

2. Two rectangles are constructed to the following proportions: One rectangle contains 40 identical squares and is 5

squares wide in one direction and 8 squares wide in the other direction. The second rectangle contains 160 identical squares and is 10 squares wide in one direction and 16 squares wide in the other direction. Are both Golden Rectangles? Explain.

3. *True or False.* A Golden Rectangle is slightly larger than a 35mm frame.

4. *True or False.* Abstract images work because there are no recognizable patterns for the brain to perceive.

5. *True or False.* The brain rejects total randomness.

6. *True or False.* Some people are turned off by abstract art forms because their brains do not detect patterns.

7. *True or False.* As someone who edits photographs, it is your job to evaluate images for order and recognizable patterns within the frame of the photograph.

8. A Golden Rectangle may either be in horizontal format, also called _____ format, or in vertical format, also called _____ format.

9. *True or False.* Although it does not reflect the natural world, the brain is stimulated by the Golden Rectangle because of its pleasing proportions.

10. Which of the following photographic print sizes closely approximates the proportions of the Golden Rectangle?
 a. 8" x 10"
 b. 8" x 12"
 c. 11" x 14"
 d. 11" x 16"

● The Principle of Thirds

The principle of thirds is sometimes referred to as the rule of thirds. In photography, as in any other art form, the only rule is that there are no rules. Many outstanding photographs have been created by ignoring the principle of thirds. But these photographs usually have other compositional factors working in their favor. The fact is, most photographers who create outstanding photographs do so by employing the principle of thirds. The principle of thirds is a recommended way of establishing balance and creating order within the photographic frame. The principle of thirds is a valuable tool that aids the photo editor in identifying images that stimulate and satisfy the brain. By utilizing the principle of thirds, the novice photo editor begins to appreciate and understand the importance of balance within a photographic frame, and quickly learns why the establishment of order and identifiable patterns is a critical element in successful photographs. Patterns, balance, and order—those intangible

The principle of thirds is sometimes referred to as the rule of thirds.

qualities that the brain searches for—are almost always found in the images of those photographers who apply the principle of thirds.

Take a Golden Rectangle—a 35mm film frame—and divide it into equal segments using the principle of thirds (see figures 2-7 and 2-8). By dividing the frame into thirds, four specific and equally balanced points within the frame have been established (where the horizontal and vertical grid lines intersect): upper left, upper right, lower left, and lower right. Notice how the principle of thirds is used to equally divide a frame in the portrait format (figure 2-7) and in the landscape format (figure 2-8).

Can a frame be divided into fourths, fifths, or sixths? Yes! Theoretically, a frame can be divided into any number of equal segments. However, as the number of segments increase, the brain finds it increasingly difficult to identify patterns. Psychological testing and extensive research have shown that dividing a frame into thirds is best, because the brain easily recognizes simple subdivisions, and balance within a rectangle (especially a Golden Rectangle) is maximized when it is divided into thirds.

12. **True or False.** The principle of thirds should be used as a tool for identifying images that stimulate the brain.

13. The _____ __ _____ helps identify those _____ qualities that the _____ searches for.

14. The qualities or critical elements almost always found in the photographic images of photographers who apply the principle of thirds are _____, _____, and _____.

Answers

12. True

13. principle of thirds, intangible, brain

14. patterns, balance, order

Figure 2-7 (left)—Principle of thirds applied to portrait format

Figure 2-8 (above, right)—Principle of thirds applied to landscape format

15. **True or False.** A 35mm frame can be divided into fifths.

16. Balance within a rectangle like a 35mm frame is _____ when divided into _____.

17. In a frame that has been divided into thirds, the intersecting horizontal and vertical grid lines establish (how many?) _____ equally _____ points.

Answers

15. True. A frame can be divided into any equal number of segments.

16. maximized, thirds

17. four, balanced

Envision a Grid System Over Your Photographs. When you look at a photograph, mentally superimpose a grid system that divides the frame of the photograph into thirds. Examine the image to see if the main elements within the frame are positioned at or near the intersection points of your mental grid. By making use of this simple mental exercise, you will dramatically improve your photo editing skills from a compositional point of view. Let's evaluate two photographic images of the same scene to see how composition is dramatically improved through the application of the principle of thirds.

Look at photograph 2-1. Most amateur photographers make the same mistake—they place the subject in the middle of the photographic frame. This makes for a very static and dull image. The author cropped the portrait format of the swing in photograph 2-1 from the landscape format of the original image in photograph 2-2

Envision a grid system over your photographs.

Photograph 2-1—Swing

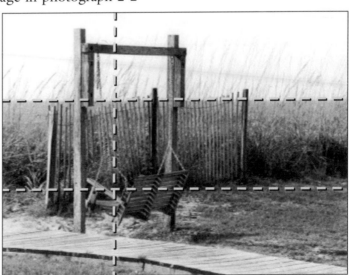

Photograph 2-2—Principle of thirds applied to the swing (Photos by David Collins)

21

for instructional purposes. The image of the swing in photograph 2-2 demonstrates how balance and order are achieved within a photographic frame through application of the principle of thirds.

In photograph 2-2, notice how the swing and the wooden frame have been positioned along the left vertical one-third line of the imaginary grid, how the swing is positioned along the lower horizontal one-third line, and how the horizon line has been positioned along the upper horizontal one-third line of the imaginary grid (dotted lines). Compare this image to photograph 2-1. The new image is more dynamic. It has been greatly improved over the static image of photograph 2-1 through application of the principle of thirds. By moving the main subject of the photograph off center and "opening up" the photographic frame to include other compositional elements that enhance and reinforce the main subject, the photographer has successfully created an aesthetically pleasing and technically perfect image. You will learn which elements go into the creation of an aesthetically pleasing and technically perfect image in lesson 4, "The Perfect Photograph."

Here's a helpful tip: Use grid templates on transparent overlays when evaluating photographs for compositional balance and order. Clear acetate sheets can be purchased in art, stationery, and camera stores. Simply outline the dimensions of several standard and full-frame print sizes using indelible ink and a straightedge. Print sizes might include 4" x 5", 5" x 7", 8" x 10", 8" x 12" (35mm full-frame), 11" x 14", and 11" x 16" (35mm full-frame). For larger photographs, use larger acetate sheets. After outlining the various print size dimensions, divide each of the frame outlines into thirds and draw in the grid pattern. Each grid template should resemble the grid pattern of figure 2-7.

Balance Points. When a photographer sees something that catches his or her eye, he or she will set the camera on a tripod and carefully study the scene through the viewfinder. A good photographer is not quick to shoot, unless the subject requires quick action (like a deer leaping through the forest or a fowl that just took to flight). A good photographer thinks of the viewfinder as a picture frame, because that is exactly what it is! As the photographer studies

18. **True or False.** Good photographers mentally superimpose an imaginary grid over the frames of their viewfinders for improving the compositional value of their photographs.

19. The imaginary grid photographers use is based on the

_____ __ _____.

20. A _____ _____ is a simple tool that will aid you in evaluating photographs for _____ _____ and

_____.

Answers

18. True

19. principle of thirds

20. grid template, compositional value, order

the scene, he or she determines what the main subject is. Is it a barn, a waterfall, or an animal basking in the sun? Once the photographer has determined what the main subject is, he or she will then apply the principle of thirds by positioning the subject at the four different balance points (intersections) along the one-third horizontal and vertical imaginary grid lines in the frame of the viewfinder. Recall that these balance points are four imaginary points within a frame as a result of applying the principle of thirds, and are located in the upper left, upper right, lower left, and lower right quadrants of the frame. The photographer must then determine at which balance point the subject looks best. The photographer will also try to place other elements that fall within the frame at or near other balance points.

Refer to photograph 2-3. Notice how the photographer positioned the tiger's head along the left vertical one-third imaginary grid line, and its body along the upper horizontal one-third imaginary grid line. Notice, too, where the vertical and horizontal grid lines intersect. This marks the position of the upper left balance point within the photographic frame. Carefully examine how most of the image of the tiger is located at or near the upper left balance point. This is only one example of how compositional balance can be achieved within the frame of a photograph by applying the principle of thirds and taking advantage of balance points.

A good photographer is not quick to shoot.

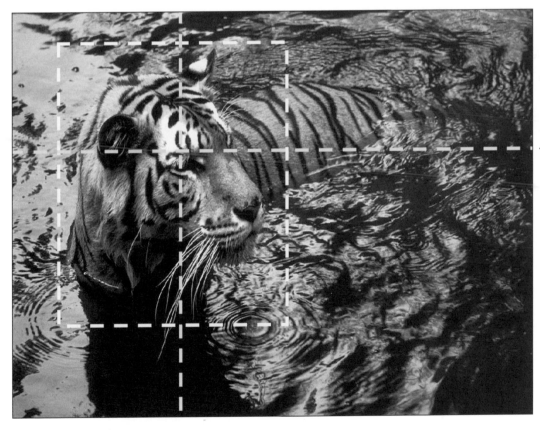

Photograph 2-3— Applying the principle of thirds within the photographic frame

21. In photograph 2-2, the swing is positioned at or near which balance point?
22. How many balance points are found within a photographic frame when applying the principle of thirds?
23. **True or False.** The photo editor can evaluate photographs for effective compositional balance and order by applying horizontal and vertical imaginary grid lines and balance points to photographic images.

Answers
21. Lower left
22. Four
23. True

24. **True or False.** You must always apply the principle of thirds to the photographs you edit and evaluate.
25. **True or False.** The main subject in any photograph must be positioned either along a horizontal or vertical one-third line, or at or near one of the four balance points within the photographic frame.
26. **True or False.** If a photographer doesn't want to use the entire image within a photographic frame, a particular area of the image may be cropped and enlarged.

Answers
24. False. The principle of thirds is only a tool and not a hard-and-fast rule.
25. False. Many outstanding photographs do not conform to the principle of thirds; however, such images usually incorporate other compositional elements.
26. True. Almost any image area within a photographic frame may be cropped and enlarged.

You must remember that the principle of thirds is just a tool to aid you in evaluating photographs for compositional balance and order. The principle of thirds will not always apply to every photographic image. There will be those instances where centered subjects—subjects within a photographic frame that are not positioned along a horizontal or vertical one-third line or are not located at or near balance points—are perfectly acceptable and may even have been centered for compositional effect. Suppose all the photographer wanted was a full-frame head shot of the tiger in photograph 2-3. The photographer might choose to frame the tiger in such a way (white dotted lines) that its head takes up most of the photographic frame in a portrait format. In this case, forget the principle of thirds and judge the photograph on other criteria that you will soon learn about. The principle of thirds generally applies to scenes; that is, photographs that contain many visual elements.

There is, of course, another alternative available to you. Suppose you decide that all you want is a full-frame shot of the tiger's head, and the only image available to you for immediate use is the shot of the tiger in the water. Simply crop the image to include only the head of the tiger, and then instruct the darkroom technician to enlarge only that portion of the photograph. You will learn more about cropping and enlarging techniques in lesson 4, "The Perfect Photograph."

Photograph 2-4—Kitten Asleep in a Log *(Photo by June Jacobson)*

Practical Application of the Principle of Thirds. Photograph 2-4, *Kitten Asleep in a Log,* illustrates how the principle of thirds is used to create compositional balance and order. It is an example of an outstanding image—it has been published in *Petersen's Photographic* and *Portfolio* magazines, and in the *Photographer's Market.* What makes this photograph so successful? First, the image represents a universal theme—the celebration of a new life (in this case, the adoration that almost everyone feels toward a little kitten). The image evokes a positive emotion that attracts the viewer to the photograph. (You will learn more about universal themes in lesson 4, "The Perfect Photograph.") Second, the image is enclosed within a Golden Rectangle, and its main elements are positioned in such a way that they satisfy the principle of thirds. The brain perceives an orderly and balanced arrangement of the elements within the frame. Notice how the kitten's head and paws have been positioned along the left vertical one-third line, and how the kitten's body follows along the lower horizontal one-third line. The log in which the kitten is positioned reinforces the pattern. Most of the image of the log runs along the left and bottom borders of the frame formed by the Golden Rectangle. In addition, the log acts as a framing device that serves to emphasize the subject. (You will learn more about framing

The principle of thirds is used to create compositional balance and order.

25

The image is simple, clean, and well-balanced.

later in this lesson.) The main elements within this photograph are located at or near the balance points where horizontal and vertical one-third lines intersect.

Do you think this image would have been just as successful had the photographer positioned the kitten's head and paws in the middle of the photograph? Probably not! Could the photographer have enhanced the photograph by including more elements in the image? Absolutely not! In fact, only those elements that are successful to the composition of the photograph are present. There are no distracting background objects and no unnecessary clutter. The image is simple, clean, and well-balanced.

● **Section Self-Test #2**

Use a separate sheet of paper to write down your responses to the following questions. Check your responses against the answers provided in appendix A.

1. The principle of thirds is a recommended way of:
 a. Identifying a Golden Rectangle
 b. Establishing balance and order within the frame
 c. Creating outstanding photographs
2. *True or False.* Balance within a rectangle like a 35mm film frame is maximized when divided into thirds.
3. In a frame that's been divided into thirds, how many balance points are created?
 a. Two
 b. Four
 c. Six
4. *True or False.* The principle of thirds is always applied to outstanding photographs.
5. *True or False.* Subjects should never be centered within a photographic frame.

Note: For questions 6 through 10, refer to photograph 2-4, *Kitten Asleep in a Log.*

6. What is the subject of the photograph?
7. How has the principle of thirds been applied to the subject? (Recall what you learned about horizontal and vertical grid lines.)
8. What other visual element is in the photographic frame? (Other than the subject, is there a secondary visual element that may be used to reinforce or distract the viewer's attention to or away from the subject?)

9. Does this other visual element add to or distract from the image? Explain why.
10. Have the balance points within the photographic frame been used to maximum advantage? Explain your answer.

● Subject Emphasis

The concept of subject emphasis is important to photo editing. Simply stated, subject emphasis involves attracting the viewer's attention to the subject within the photographic frame through the use of various compositional techniques.

27. **True or False.** Subject emphasis involves attracting the viewer's attention to the main subject within a photographic frame.

Answer
27. True

The concept of subject emphasis is important to photo editing.

Before continuing any further, let's differentiate between a subject and a theme. Although they are closely related, there is a significant difference.

With respect to photography, a subject is a thing that can be physically dealt with, such as a flower, an animal, or a person, and graphically fixed in its actual form. A theme, with respect to photography, then, is an idea or concept that cannot be physically dealt with, and must be expressed in an abstract way: war or peace, happiness or sorrow, love or hate, for example. The most successful photographic images contain universal themes. You will learn more about universal themes in lesson 4, "The Perfect Photograph."

28. A subject is a _____ that can be physically photographed.
29. A theme is an _____ or _____ that (can/cannot) _____ be physically dealt with, and must be expressed in an _____ way.
30. The most successful photographic images contain _____ _____.

Answers
28. thing
29. idea, concept, cannot, abstract
30. universal themes

Evaluate the subject's placement within the photographic frame.

Placement. This is where the principle of thirds works to your advantage in editing photographs. The first and most important editing function is to evaluate the subject's placement within the photographic frame. Usually, the subject is emphasized by placing it near the center of the frame. But what does near the center mean? Dead center? Slightly off center? The answer is found in the principle of thirds. By dividing the frame into three vertical parts, and placing the subject at or near one of the two vertical dividing lines, the subject becomes pleasingly balanced and less static than had the subject been placed directly in the center of the frame. The mind perceives balance because the subject occupies one-third of the frame and empty space fills two-thirds of the frame. In other words, the smaller occupied space is balanced—compositionally speaking—by the larger unoccupied space.

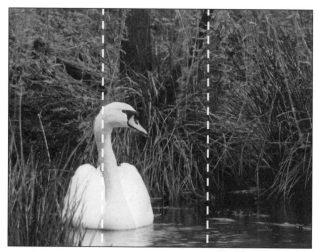

Photograph 2-5—Swan looking inward toward center of photographic frame

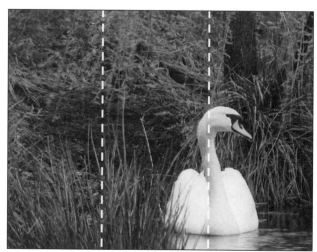

Photograph 2-6—Swan looking outward away from center of photographic frame

31. The principle of thirds works because a subject occupies
_____-_____ of the photographic frame and space
occupies _____-_____ of the frame, giving a pleasingly _____ and less _____ composition.

Answer

31. one-third, two-thirds, balanced, static

In photograph 2-5, the swan has been placed on the left dividing line (white dotted line). The swan could also have been placed on the right dividing line, as shown in photograph 2-6. However, positioned on the right dividing line, the swan would be looking out of the frame—compositionally awkward, at best. By positioning the

swan on the left dividing line, the swan is looking inward toward the center of the frame, or into the space provided by the frame—a more visually pleasing placement. Here, then, is an important principle of subject placement: If the subject is looking toward the left or right—that is, the subject is not looking directly forward—position the subject so that the subject is facing inward toward the center of the frame. If the subject is looking toward the left of the frame, place the subject at or near the right dividing line; if the subject is looking toward the right of the frame, place the subject at or near the left dividing line. Does this mean the subject should never be placed directly in the center of the frame? No! But unless there is a good reason for placing the subject directly in the center of the frame, the best choice is to follow the time-honored principle of thirds.

Relative Size. Another way a subject is emphasized is through relative size. Photograph 2-7 contains many people within its frame. One particular person, President Clinton, stands out from all the rest. Why? The president is larger than the others. The photographer positioned the president closer to the lens of the camera. He fills more of the frame than all the other people in the photograph. The

32. **True or False.**
 Generally, subjects positioned directly in the center of a frame are static.

33. If a person is looking toward the left or right—that is, the person is not looking directly forward—position the person so that he or she is facing _____ toward the _____ of the frame.

34. **True or False.**
 A subject should never be placed directly in the center of a frame.

Answers

32. True

33. Inward, center

34. False

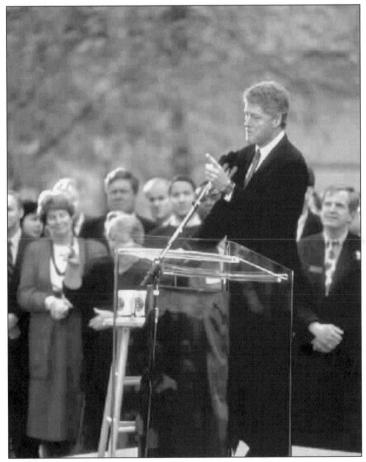

Photograph 2-7—Example of subject emphasis through relative size

35. True or False.

In photograph 2-7, the president commands our attention because he seems larger than everyone else.

Answer

35. True

others are farther back and appear to be much smaller. In reality, of course, everyone within the frame is about the same height. But the subject's relative size (the president), compared to everyone else in the frame, places the emphasis on him. Our eyes are automatically drawn to him. This is a classic example of subject emphasis through relative size.

Notice that the president is facing inward toward the center of the photographic frame, making effective use of subject emphasis through placement. Another subject-emphasis technique employed in this photograph is selective focusing, which is explained later in this lesson. Outstanding photographs often employ more than one technique for emphasizing the subject.

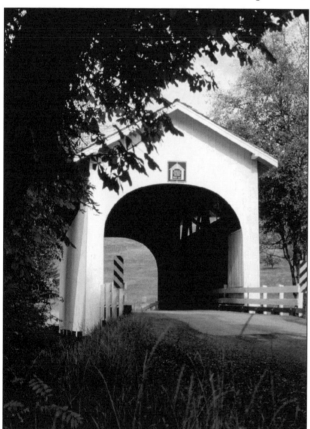

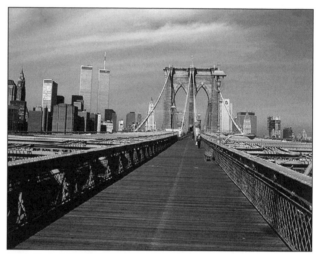

Photograph 2-8—Example of subject emphasis through framing (left)

Photograph 2-9—Example of subject emphasis through converging lines (right)

Framing. A subject is also emphasized through framing. Do not confuse subject framing with the frame of a photograph. While the frame of a photograph is represented by its maximum height and width dimensions, subject framing accents a subject through other elements in the photograph.

Notice how the leaves of the tree in photograph 2-8 are used to frame the covered bridge, thereby directing our attention to the main subject. Framing, in this case, has been made even more effective through selective focusing. The main subject, the covered bridge, is in sharp focus, while the leaves and branches of the tree, the grass

framing the bridge in the left foreground, and the tree in the right background are slightly out of focus.

Converging Lines. In photograph 2-9, the subject of the picture is the vertical bridge structure at the end of the long walkway. Notice how the lines of the walkway start at each corner of the photographic frame and converge toward the subject. These converging lines form a pathway that forcibly draws our eyes directly to the vertical structure. Although the wide space created by the open walkway in the foreground is the most dominant feature in the photograph, the converging lines of the walkway nevertheless direct our immediate attention to the vertical structure off in the distance. This is an excellent example of subject emphasis through the use of converging lines.

The same effect is achieved with railroad tracks. Almost everyone is familiar with the image of the converging tracks. Place a train at the end of the tracks, far off in the distance, and our eyes will automatically be drawn to the train even though the train is the smallest element in the photograph. Because the converging lines of the tracks direct our eyes to the train, it is the train that becomes the main subject.

This is an excellent example of subject emphasis. . .

36. **True or False.** Framing is a technique used by photographers for accenting a subject through other elements in the photograph.
37. **True or False.** Distant subjects can be effectively emphasized through the use of converging lines.

Answers

36. True
37. True

Selective Focusing. In photograph 2-10, our eyes are immediately drawn to the subject. Why? Because the athlete—the subject of the photograph—is in sharp focus, while everything else around him has been thrown out of focus. Notice, too, that the concept of relative size has also been employed in this photograph. The subject has been made big and bold through a close-up shot, and fills the entire photographic frame. By utilizing more than one subject-emphasis technique in a photograph—as has been done in photograph 2-10—our eyes are forcibly drawn to the main subject of the photograph. As stated earlier, outstanding photographic images that command a viewer's attention often employ several subject-emphasis techniques for accentuating the main subject within the photographic frame.

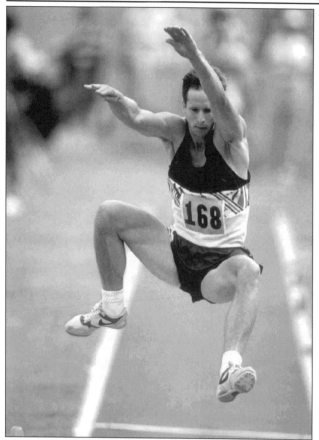

Photograph 2-10—Example of subject emphasis through selective focusing

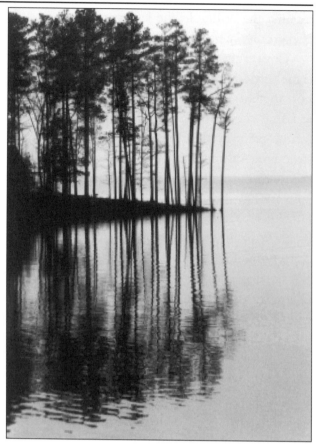

Photograph 2-11—Example of subject emphasis through repetition (Photo by David Collins)

38. True or False.
By focusing sharply on a subject, and throwing everything else in the photographic frame out of focus, the subject is strongly emphasized.

39. True or False.
Repetition simply means that repeated images are found within the same photographic frame.

Answers

38. True

39. True

Repetition. In photography, repetition simply means repeated images. Most of us are familiar with the image in a mirror in a mirror shot. If two mirrors are placed adjacent to one another at a 45° angle, the image in the mirror repeats itself an infinite number of times. In photograph 2-11, the image of the trees reflected in the lake is a classic example of repetition created by a mirrored (or reflected) image.

Rowboats lined up side-by-side on a lake, fence posts running along an open field, and architecturally similar houses that line a street are also examples of repetition. In these examples, although the repeated images are not identical—as they are in mirrored images—they are nevertheless similar enough to one another to make the mind perceive a pattern of repetition.

Motion. Anyone who views photograph 2-12 feels the forward motion of the aircraft within the frame. The viewer perceives that the aircraft is flying. The blurred field beneath the aircraft and the blurred propellers create the feeling of motion. Consider how dull this photograph would be if both the aircraft and the background were frozen and there was no feeling of motion. There are three ways in which the feeling of motion can be conveyed: subject is blurred

and the background is still; subject is still and the background is blurred (as in photograph 2-12); both the subject and the background are blurred.

Which is the best method of the three for emphasizing motion? There is no best method. It is entirely subjective. Just keep in mind that a photograph that is supposed to impart a feeling of motion to the viewer should incorporate one of the methods listed above for maximum effect.

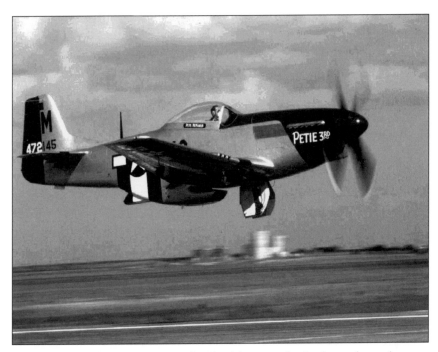

Photograph 2-12—Example of subject emphasis through motion

Visual Layering. Visual layering is a more complicated concept, but it gives a photograph a powerful three-dimensional effect that is found in some truly outstanding photographic images. *National Geographic* photographers take two basic approaches to photographic composition. One approach utilizes only two elements in a photograph: subject and background. In this kind of composition, the subject stands out in sharp focus against an out of focus background. Does this remind you of a particular subject emphasis technique? It is selective focusing, where the subject is in sharp focus and everything else around the subject is out of focus.

The second approach incorporates visual layering within the photographic frame, where the viewer sees something happening in the foreground, middle ground, and background. For example, a tiger in the foreground may be watching a gazelle in the middle ground, while birds are perched upon a tree in the background. In this kind of composition, you must be careful not to confuse the viewer. Is the tiger or the gazelle the main subject? What about the birds in the

40. True or False.

The best method to use for emphasizing a subject in motion is to blur both the subject and the background.

Answer

40. False. There is no best method.

33

Generally, the
subject in the
foreground is the
main subject.

tree? Generally, the subject in the foreground is the main subject (subject emphasis through relative size). However, if the photographer focused sharply on the gazelle, leaving the tiger and the birds slightly out of focus, then the gazelle becomes the main subject.

Visual layering, then, creates a powerful three-dimensional effect by incorporating elements in the foreground, middle ground, and background within the photographic frame. For ultimate visual impact, there should be something happening or something of interest to the viewer in at least two of the three layers, with the sharpest focus on the main subject. The impact created by layering is somewhat diminished if there is only one subject, and that subject is in the foreground. This is because the subject will command our full attention and the middle ground and background will be ignored by the viewer.

Some people confuse the concepts of visual layering and selective focusing. Both visual layering and selective focusing techniques employ the concept of sharply focusing on the main subject and keeping everything else within the photographic frame out of focus. However, visual layering requires a distinct separation between foreground, middle ground, and background, with two of the three layers being slightly out of focus. This allows the viewer to see something of interest in each layer. Selective focusing usually obscures everything around the main subject. The primary purpose of selective focusing is to direct the viewer's attention only to the subject.

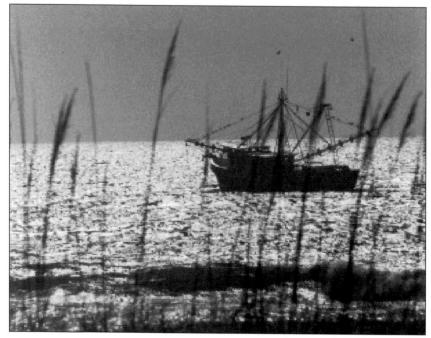

Photograph 2-13—Example of subject emphasis through visual layering (Photo by David Collins)

Photograph 2-13 illustrates subject emphasis through visual layering. The silhouette of this shrimp boat was photographed through a layer of sea oats along a sand dune. The sea oats in the foreground are out of focus, forcing the viewer's attention to the sharply-focused shrimp boat in the middle ground. Birds can be seen in the background. Notice how the sea oats in the foreground and the birds in the background are only slightly out of focus. The foreground and background are not completely out of focus, and the viewer can still see something of interest in each layer. The horizon line of the water clearly separates the background from the middle ground and adds a sense of three-dimensional depth to the picture.

In addition, notice how the photographer took advantage of the principle of thirds by positioning the shrimp boat along the right vertical one-third line, and by positioning the horizon line of the water along the upper horizontal one-third line. In keeping with the concept of subject emphasis through placement, the shrimp boat is moving inward toward the center of the frame instead of moving away from the center and out of the frame.

The foreground and background are not completely out of focus.

41. **True or False.** A good example of visual layering would be selectively focusing on a subject in the middle ground with the background slightly out of focus.
42. Visual layering creates a powerful _____-_____ effect by incorporating the _____, _____ _____, and _____ within the photographic frame.
43. For ultimate visual impact in visual layering, there should be something happening in at least _____ of the visual layers.
44. A photographer comes across a scene with bushes in the foreground, a hunter in the middle ground, and a deer in the background. To make the hunter the main subject, while preserving visual layering, what should the photographer do?
45. A woman is photographed in an open field. The photographer focuses sharply upon the subject. Everything around the subject is completely out o focus. However, the photographer included a large area of foreground and a large area of background in the photographic frame. Is this an example of visual layering?

Answers
41. False. Visual layering must include the foreground, middle ground, and background. Focusing sharply on the subject and keeping the background out of focus is characteristic of selective focusing, not visual layering.
42. three-dimensional, foreground, middle ground, background
43. two
44. Focus sharply on the hunter in the middle ground, keeping the foreground and background slightly out of focus. The viewer must be able to clearly recognize the deer in the background.
45. No! In the photograph of the female subject, everything around the subject is completely out of focus—including the foreground and background. There is no separation of foreground, middle ground, and background layers. This is an example of selective focusing.

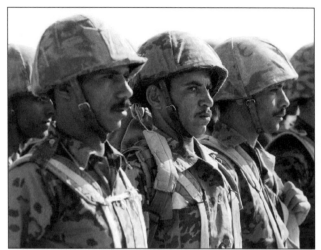

Photograph 2-14—Absence of geometric forms

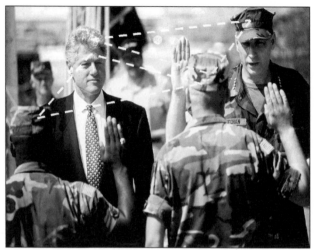

Photograph 2-15—Subject emphasis through the use of geometric forms

46. True or False.

Geometric forms like converging lines and imaginary triangles can dramatically improve your photographic compositions.

Answer

46. True

Geometric Forms. You've already learned about subject emphasis through converging lines. It is one type of geometric form that is utilized in photographs. Another important geometric form in photography is the triangle.

Photograph 2-14 illustrates a very static portrait of three people all positioned at the same height. Although it is a good photograph, there is no interaction between the people in the photograph (the subjects) and the viewer, and the viewer feels no involvement with the image. Photograph 2-14 is simply a picture of three soldiers.

Photograph 2-15 illustrates how an image can be dramatically improved through the imaginary placement of a geometric form—a triangle. In photograph 2-15, if we draw lines connecting each of the subjects' heads, we find that we have drawn a triangle. In other words, the subjects' heads are located at or near points on an imaginary triangle. Note that there is more than one triangle (two sets of triangular-shaped dotted lines). Generally, more triangles represent more dynamics in a photograph.

Compare the image of photograph 2-14 to the image of photograph 2-15, and observe how the introduction of a geometric form has dramatically improved viewer involvement in the photograph. In photograph 2-15, our eyes move all around the image and we become involved in the dynamics of the moment. This particular image also demonstrates communication in photographs, the topic of the next section in this lesson. We detect a sense of communication between the president and the soldiers, and between the soldiers themselves. When photographs possess communicative qualities, viewers tend to get more involved with them.

● Section Self-Test #3

Use a separate sheet of paper to write down your responses to the following questions. Check your responses against the answers provided in appendix A.

1. Subject emphasis involves:
 a. The application of the principle of thirds
 b. Drawing attention to the subject through framing
 c. Attracting the viewer's attention to the subject within the photographic frame through the use of various compositional techniques

2. Subject emphasis through placement means:
 a. Placing the subject at a specific position within the photographic frame to achieve balance
 b. Always placing the subject within the photographic frame according to the principle of thirds
 c. Always centering the subject within the photographic frame

3. Subject emphasis through relative size means:
 a. Large people always command our attention
 b. Emphasizing the subject by placing it closer to the lens of the camera, making the subject seem larger than it really is
 c. Emphasizing the subject by focusing sharply on it

4. Subject emphasis through framing means:
 a. The technique used by photographers to accent a subject through other elements in the photograph
 b. Focusing sharply on the subject within the photograph
 c. The positioning of a photograph within a picture frame

5. Subject emphasis through converging lines means:
 a. A compositional technique for focusing attention to a distant subject or object
 b. A geometrical form used in conjunction with visual layering
 c. A technique that is used for photographing railroad tracks

6. Subject emphasis through selective focusing means:
 a. Emphasizing a subject by filling the entire frame with it
 b. Throwing everything out of focus within the photographic frame except for the subject
 c. Having the subject look directly into the camera's lens

7. Subject emphasis through repetition means:
 a. Multiple frames of the same image
 b. Shooting the same image with different exposures

 c. Repeated images that are found within the same photographic frame

8. Subject emphasis through motion means:

 a. Emphasizing the subject by giving it a feeling of motion

 b. The perception of motion even when there is none

 c. The blurring effect caused by unintentional camera movement

9. Subject emphasis through visual layering means:

 a. Incorporating at least two of the three visual layers in a photograph

 b. Creating a powerful three-dimensional effect where the viewer sees something happening in the foreground, middle ground, and background within the photographic frame

 c. Composing the subject through a framing device, such as the leaves and branches of a tree

10. Subject emphasis through geometric forms means:

 a. Incorporation of abstract art forms into the photograph, which may or may not attract the interest of the viewer

 b. The perception of shapes and forms created by the shadows of special lighting arrangements

 c. Geometric forms like converging lines and imaginary triangles that can dramatically improve photographic composition

● Communication in Photographs

Did you know that people, animals, and objects can communicate with each other in photographs? By communicating with each other, they communicate to the viewer. In photograph 2-15, the subjects are communicating with one another simply by looking at each other. The president is communicating with the soldier in front of him simply by looking at him. The soldier standing next to the president and facing the viewer is also communicating with the same soldier.

Animals can communicate to other animals, and to the viewer, too. Photograph 2-16 illustrates a wild animal snarling into the lens of a camera, communicating anger, danger, and violence to the viewer—all universal themes. Another example of animals communicating with the viewer is a puppy with saddened eyes laying near his empty food bowl—the universal theme of hunger. A photo of two chimpanzees sitting face-to-face in a zoo, one holding a banana and the other peeling back the skin, communicating the concept of sharing, illustrates another universal theme.

Animals and objects can communicate with each other in photographs.

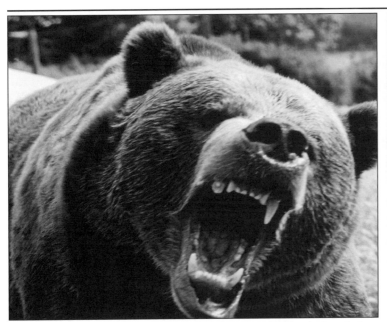

Photograph 2-16—Example of communication by animals in photographs

Photograph 2-17—Example of communication by inanimate objects in photographs

What about inanimate objects? Can they communicate? Yes, they can! Photograph 2-17 clearly illustrates the concept of communication through inanimate objects. In this photograph, there are no humans or animals within the frame. The viewer only sees pink roses against a dark background. But look closely at the composition and placement of the elements in the photograph. All the roses are standing tall with their petals stretched upward toward the sky as if they are delighted to receive the life-sustaining rays of the sun. The viewer can feel the roses communicating their desire for the warm sunlight.

The principle of thirds is also wonderfully illustrated in photograph 2-17. The tallest rose is positioned at or near the intersection of the right vertical one-third imaginary grid line and the upper horizontal one-third imaginary grid line, or the upper right balance point. The larger rose is positioned at or near the intersection of the right vertical one-third imaginary grid line and the lower horizontal one-third imaginary grid line, or the lower right balance point. The smaller rose near the bottom of the photographic frame is positioned at or near the intersection of the left vertical one-third imaginary grid line and the lower horizontal imaginary one-third grid line, or the lower left balance point. Notice the geometric form (triangle) that is created in this photograph by drawing imaginary lines from the upper right balance point to the lower right balance point, from the lower right balance point to the lower left balance point, and finally from the lower left balance point back to the upper right balance point.

47. **True or False.**
Animals can communicate with other animals within a photograph and to the viewer of the photograph, too.

48. **True or False.**
Inanimate objects, such as flowers and trees, cannot communicate in photographs.

Answers

47. True

48. False. Inanimate objects can project a feeling of communication.

● Section Self-Test #4

Use a separate sheet of paper to write down your responses to the following questions. Check your responses against the answers provided in appendix A.

What is the single most prominent element in the photograph?

1. *True or False.* Inanimate objects in photographs can communicate with each other just as people and animals can communicate with each other.
2. *True or False.* The feeling of communication in a photograph can dramatically enhance its visual impact.
3. *True or False.* The feeling of communication and a balanced image are two important ingredients that go into outstanding photographs.
4. What has the photographer done to balance the image in the photograph of the roses?
 a. The photographer positioned the roses symmetrically within the photographic frame to achieve a sense of balance.
 b. The photographer positioned the roses along the right vertical one-third line and along the lower horizontal one-third grid line.
 c. The photographer positioned the taller rose at or near the upper right balance point, the larger rose at or near the lower right balance point, and the smaller rose at or near the lower left balance point, thereby creating both balance and a geometric form within the photographic frame.
5. What is the single most prominent element in the photograph of the roses that successfully projects a feeling of communication within the photographic frame?
 a. The quality of light within the photograph.
 b. The way in which the roses are arranged within the photographic frame.
 c. The way the roses seem to be stretching upward as if they are delighted to be receiving the life-sustaining rays of the sun.
 d. The positions of the roses at or near balance points.
6. In the photograph of the snarling bear, which of the following choices correctly describes the placement of the subject within the photographic frame?
 a. The subject's head is positioned along the upper horizontal one-third line of the photographic frame and its open mouth is positioned at or near the upper right balance point.

b. The subject's head is positioned along the left vertical one-third line of the photographic frame and its open mouth is positioned at or near the lower right balance point.

c. The subject's head is positioned at or near the upper right balance point of the photographic frame and its open mouth is positioned at or near the lower right balance point.

● Lesson Summary

Before moving on to lesson 3, "Colors, Tones, and Exposure," make sure that you have learned all about the concepts of patterns, balance, and order within the photographic frame. You should now have a thorough understanding of the following concepts, and you should know how to apply these concepts to photographic images for the purpose of selecting and evaluating photographs for publication:

- The Golden Rectangle
- The importance of patterns within the Golden Rectangle
- The principle of thirds
- Balance points
- Subject-emphasis techniques
- Communication in photographs

You should know how to apply these concepts...

Colors, Tones, and Exposure

Photo editors scrutinize images for correct color saturation.

● Introduction

In this lesson, you will learn about color saturation and color balance, fidelity and contrast, the importance of color tones in black and white photographs, gray tones, the Zone System, and how to properly use a gray scale. You will learn to distinguish between soft focus, selective focus, out of focus, poorly focused images, and camera shake. Most importantly, you will learn how to identify properly exposed photographs. You will learn how to use the photo editor's magnification loupe to examine photographs for image sharpness and proper exposure. You will also learn to use the Zone System gray scale for evaluating black and white photographic images, and the color wheel for working with color photographs. The photographs in this lesson demonstrate how the concepts of colors, tones, and exposure are applied in each of the photographic frames.

● Color Characteristics

There are four color characteristics that you should concern yourself with as a photographer who wishes to market his or her photos: color saturation, color balance, color fidelity, and color contrast.

Color saturation refers to the intensity of the colors in the photograph. Photo editors scrutinize images for correct color saturation: Are blues really blue, or have they taken on a purple or violet color? Are reds really red, or have they taken on a pink color? Are greens really green, or have they taken on a chartreuse color? Colors that are not saturated are pastel or muted colors. They look misty. Saturated colors command more attention.

Color balance includes two general categories: accurate color reproduction and color cast. With respect to accurate color reproduction, a photo editor will examine an image to determine whether the colors in the photograph have been accurately reproduced as they

1. True or False.
Pastel or muted colors are examples of saturated colors.

Answer
1. False

appeared in the original scene. Although there is a certain amount of subjectivity involved here—the photo editor doesn't really know what the original scene looked like—the photo editor does know what an open field of grass should look like. Or what a cloudy sky looks like just before it rains. Or that human flesh tone shouldn't appear pink in portraits. In other words, just from experience in the real world, the photo editor should be able to discern a believable color scheme from a

2. **True or False.** Color balance refers to both accurate color reproduction and color cast.

3. **True or False.** Generally, the use of daylight film under incandescent or fluorescent lighting will not cause a color cast.

4. **True or False.** Color casts are sometimes used for the purpose of intensifying a photograph's overall impact.

Answers

2. True

3. False. Daylight film used under incandescent lighting will cause a yellow color cast, and daylight film used under fluorescent lighting will cause a green color cast.

4. True

contrived manipulation of colors—or colors that have not been faithfully reproduced—within the photographic frame. Fire trucks are usually bright red and not dark orange; milk is white and not light gray; human eyes are blue or green or brown, and not red. Of course, there are photographic images that have been deliberately color-manipulated for effect, and these types of images must be edited with that purpose in mind.

With respect to *color cast,* a photo editor will examine an image for overall coloration. For example, there may be an overall yellow or magenta or green hue that predominates the entire photograph. This is a color cast. A color cast may be any color, and is caused by many different things. Some of the reasons color casts occur are:

- An exposure error by the photographer
- A developing error in the darkroom
- Use of the wrong type of film (Daylight film under incandescent lighting causes a yellow color cast while daylight film under fluorescent lighting causes a green color cast.)
- Shooting photographs in open shade (creates a blue cast that can be easily corrected by using fill-in flash or a compensating filter)
- Reflected light off of immediate surroundings (colored walls can cause color casts; light reflected off snow will cause blue color casts)
- Unintentional use of the wrong filter (The use of a yellow filter to darken the sky in a color photograph will cause a yellow cast.) A yellow filter is used to darken the sky in black and white photographs.

Some color casts are created for dramatic effects. For example:

- Photographs taken at dawn have a golden cast, giving the image a feeling of being bathed in the morning sun.
- Photographs taken in the late afternoon have a yellowish cast, giving the image a feeling of warmth.
- Photos taken at sunset have a reddish cast, enhancing the feeling of the setting sun and day fading into evening.

Filters are sometimes used to intentionally create color casts for the purpose of intensifying an image's overall impact. For example, a photograph of a sunset will contain an overall reddish cast, but the sky will still exhibit some of its blue color and the clouds will still exhibit some of their white or gray colors. Add a red filter, and the image becomes predominantly red, with a red sky and red clouds. You must define your intentions for using the photograph, and then evaluate the image on that basis.

Color fidelity refers to the faithful color reproduction of the original scene or subject. Although closely related, do not confuse color balance with color fidelity. A red rose should be red, a green leaf should be green, a field of gold wheat should be gold, and a skin tone should be as close to a natural skin tone as possible. These are characteristics of color balance. In real life, however, all the roses in a vase are not all the same shade of red. Some are bright red, some dark red, and some are different shades in between bright red and dark red. This is what color fidelity is all about—reproducing the colors in a photograph as they appeared in the original scene. Some photographs look too artificial because a photographer might have all the roses reproduced as bright red through darkroom manipulation.

Color contrast refers to the distinguishable differences—or lack of differences—between the lightest and darkest shades of the same color. When a photo editor examines a photograph for color contrast, he or she is looking at the difference between the lightest reds and the darkest reds. . .the lightest blues and the darkest blues. . .the lightest greens and the darkest greens, etc. With respect to color contrast, a photograph exhibits high-contrast or low-contrast colors.

In a high-contrast color photograph, the difference between dark red and medium red, and medium red and light red, is clearly distinguishable. In other words, the difference between any two closely-related shades is readily and easily identifiable in a high-contrast color photograph. For example, a photograph of a bright red apple sitting on a dark red tablecloth would yield a variation in the rendering of each separate shade.

5. True or False.
Color fidelity refers to color enhancement of the original scene or subject by a darkroom technician.

6. True or False.
Color contrast refers to the distinguishable differences between the lightest tones and the darkest shades of the same color.

Answers
5. False
6. True

In a low-contrast color photograph, the difference between any two closely-related shades of red is nearly indistinguishable, and there may be half a dozen different shades between a dark red and a medium red. For example, in a photograph taken with low-contrast color film, you might not even notice a dark red napkin sitting on a slightly darker tablecloth because of the similar shades of red.

● Section Self-Test #1

Use a separate sheet of paper to write down your responses to the following questions. Check your responses against the answers provided in appendix A.

1. The four color characteristics that a photo editor is concerned with are:
 a. hues, tints, shades, and tones
 b. saturation, balance, fidelity, and color cast
 c. saturation, balance, fidelity, and contrast
 d. color cast, saturation, balance, and exposure

2. Color saturation refers to:
 a. Accurate reproduction of the color in the original scene
 b. The distinguishable differences between the lightest and darkest shades of the same color
 c. The intensity of the colors in the photograph

3. Color balance refers to:
 a. The faithful reproduction of colors as they appeared in the original scene
 b. The overall coloration of the photograph
 c. Both accurate color reproduction and color cast

4. Color fidelity refers to:
 a. The faithful color reproduction of the scene or subject
 b. Overall coloration of the photograph
 c. The intensity of the colors in the photograph

5. Color contrast refers to:
 a. The distinguishable differences between the lightest tones and darkest shades of the same color
 b. The overall coloration of the photograph
 c. The intensity of the light and dark areas in the highlights and shadows of the photograph

6. The difference between high-and low-contrast color photos is:
 a. Shades of the same color in high-contrast images are clearly distinguishable and shades of the same color in low-contrast photographs are nearly indistinguishable.
 b. Shades of the same color in high-contrast photographs are nearly indistinguishable and shades of the same

The four color characteristics that a photo editor is concerned with are. . .

color in low-contrast photographs are clearly distinguishable.

c. Shades of the same color in both high-contrast and low-contrast photographs are clearly distinguishable; it is the color saturation that makes the difference.

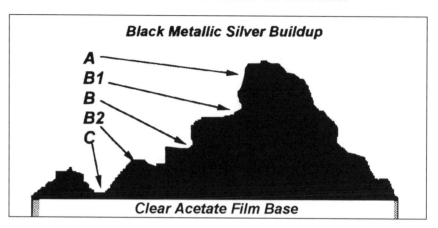

Figure 3-1—Cross section of an exposed negative

The silver buildup is what gives the negative its image.

● Black and White Exposure

When a photographer exposes black and white film correctly, he or she should end up with a print in which all the color tones in the original scene are represented by pure whites, pure blacks, and dramatically strong and varying shades of gray in between. This section will give you the knowledge necessary for understanding how black and white photographs are exposed and developed.

Figure 3-1 illustrates a cross section of a black and white negative after it has been developed. The series of mountains and valleys in figure 3-1 represent the buildup of black metallic silver.

The silver buildup is what gives the negative its image. Large amounts of light striking the negative create large buildups of black metallic silver; moderate amounts of light create moderate buildups of black metallic silver; small amounts of light create small buildups of black metallic silver. In those areas of the negative where weak or no light strikes the negative, there is no silver buildup.

Where large amounts of black metallic silver are built up on the negative (the area marked A in figure 3-1), the negative will appear black. Where small amounts of silver are built up (marked C), the negative will appear nearly transparent or very light gray. Where moderate amounts of silver are built up (marked B), the negative will appear anywhere from light gray to dark gray, depending on the amount of light received. The higher the buildup of black metallic silver, the darker the gray. For example, the area marked B represents a moderate amount of silver buildup or medium gray, B1 represents a heavily moderate buildup or dark gray, and B2 represents a lightly

moderate buildup or light gray. Where weak or no light strikes the negative, there is no black metallic silver buildup and that area of the negative is clear.

When a print is made from the negative in figure 3-1, the tones will be reversed (which is why we call the exposed film a negative). The area marked A will appear as pure white in the print; the clear areas on the negative where no silver buildup occurred will appear as pure black; the area marked C will appear as very dark gray and the area marked B will appear as anywhere from light gray to dark gray, but opposite that of the negative. For example, B1 would appear as light gray in the print (dark gray in the negative) and B2 would appear as dark gray in the print (light gray in the negative).

9. Areas on a negative that are black (heavy buildup of black metallic silver) will appear as _____ in the finished print; areas on a negative that are clear will appear as _____ in the finished print.

Answer
9. white, black

Bright areas in a scene are called highlights; dark areas in a scene are called shadows. Highlights are bright in the original scene, dark in a negative, and bright in the print. Shadows are dark in the original scene, light in the negative, and dark in the print.

Where Does the Black Metallic Silver Come From? Film emulsion is made up of microscopic crystals called silver-halide. These crystals are extremely light-sensitive. When these crystals are struck by light they are altered chemically, so that they form crystals of black metallic silver during the development process. The black metallic silver remains on the acetate base of the negative. On those areas of the negative that have not been struck by light, the silver-halide crystals are not altered chemically and are washed from the acetate base during development, exposing the base and creating a clear area on the negative.

10. Black metallic silver is formed from light-sensitive crystals called _____-_____ during the _____ process.

Answer
10. silver-halide, development

To clearly illustrate this process, let's look at two examples that we have all experienced at one time or another: accidental exposure of an entire roll of film, and turning in an unexposed roll of film for development. What happens when an entire roll of film is accidentally exposed? Not realizing there is a nearly finished roll of film in your camera, you pop open the back and expose the film to bright sunlight. All the silver-halide crystals are flooded with light. The film is developed and the silver-halide crystals turn into black metallic silver. The resulting negative is totally black.

What happens when you turn in an unexposed roll of film for development? You find a roll of film and you aren't sure it has been exposed. Not wanting to chance losing the images that might be on the roll of film, you give it to a lab for development. None of the silver-halide crystals were exposed to light. In the development process, the silver-halide crystals are not turned into black metallic silver and are simply washed from the film. The resulting negative is nothing but a clear acetate base.

What happens when you develop a roll of film that has been exposed under normal picture-taking conditions? Some areas of the film will receive large amounts of light, some areas of the film will receive smaller amounts of light, and some areas of the film will receive no light. Areas of the film that received large amounts of light will have all of the silver-halide crystals converted into black metallic silver. Those areas of the negative will be black. Areas of the film that received smaller amounts of light will have some of their silver-halide crystals converted into black metallic silver, with the remaining unaffected silver-halide crystals being washed away in development. Those areas of the negative will be dark gray. Areas of the film that received even less amounts of light will have very few of their silver-halide crystals converted into black metallic silver, with most of the remaining unaffected silver-halide crystals being washed away in development. Those areas of the negative will be light gray. Areas of the film that received no light will have none of their silver-halide crystals converted into black metallic silver, and all the unaffected silver-halide crystals will be washed away in development. Those areas of the negative will be clear.

● Section Self-Test #2

Use a separate sheet of paper to write down your responses to the following questions. Check your responses against the answers provided in appendix A.

1. *True or False.* A properly exposed black and white photograph should contain pure white, pure black, and dramati-

11. **True or False.**

When an accidentally exposed roll of film is developed, all the silver-halide crystals are washed away.

Answer

11. False. All the silver-halide crystals turn into black metallic silver.

cally strong and varying shades of gray in between.

2. *True or False.* Silver-halide crystals are the light-sensitive microscopic particles that are found in film emulsion.

3. *True or False.* Black metallic silver is converted into silver-halide crystals during the development process.

4. *True or False.* Where large amounts of silver-halide crystals are exposed to light, the resulting negative will appear black.

5. *True or False.* Unexposed silver-halide crystals are washed from the film base during development.

6. Areas of film that receive large amounts of light will have _____ of the silver-halide crystals converted into black metallic silver.
 a. all
 b. some
 c. none

7. Those areas of the negative (in question 6) will be _____.
 a. clear
 b. black
 c. gray

8. Areas of film that receive smaller amounts of light will have _____ of the silver-halide crystals converted into black metallic silver.
 a. all
 b. some
 c. none

9. Those areas of the negative (in question 8) will be _____.
 a. clear
 b. black
 c. gray

10. Areas of film that receive no light will have _____ of the silver-halide crystals converted into black metallic silver.
 a. all
 b. some
 c. none

11. Those areas of the negative (in question 10) will be _____.
 a. clear
 b. black
 c. gray

12. You examine a negative after development. It's totally black. What does this tell you?
 a. The film was exposed to bright light and the silver-

You examine a negative after development. It's totally black. What does this tell you?

halide crystals were converted into black metallic silver during the development process.

 b. The film was exposed to bright light and the black metallic silver was converted into silver-halide crystals during the development process.

 c. The film was unexposed and all the silver-halide crystals were washed away during the development process.

13. You examine a negative after development. It is totally clear (transparent acetate base). What does this tell you?

 a. The film was never exposed and the silver-halide crystals, having received no light, were not converted into black metallic silver. During the development process, all the unaffected silver-halide crystals washed away.

 b. The film was exposed and the silver-halide crystals, having been flooded with light, were converted into black metallic silver. During the development process, all the black metallic silver was washed away.

● Understanding Color Exposure

When a photographer exposes a frame of color film correctly, he or she should end up with a transparency (slide) or print in which all the colors are saturated and true to the original scene. This section will give you the knowledge necessary for understanding how color photographs are exposed and color-corrected during and after development.

Let's begin this section on understanding color exposure with a surprising fact: All color films rely on silver-halide crystals to create a black and white image during exposure and development. Surprised? Here's another fact: If you understand the concept behind the exposure and development of black and white film, you shouldn't have any problems understanding the concepts behind the exposure of color film and the color-correction process.

Color Theory. Our brains perceive color from the way light is reflected, transmitted, or absorbed by objects. White light is really a combination of reds, oranges, yellows, greens, blues, and violets. A rose is red because the red wavelengths of white light are being reflected from the petals of the rose to your eye. The rose is absorbing all the other colors of the white light. Reflected and transmitted wavelengths of light can be seen and recorded on film; absorbed wavelengths of light cannot be seen and cannot be recorded on film. The red rose doesn't appear yellow to you, because the yellow wavelengths of light are being absorbed by the rose. Likewise, the red rose doesn't appear green to you, because the green wavelengths of light are being absorbed by the rose. The stem of the rose appears green

White light is really a combination of reds, oranges, yellows, greens, blues, and violets.

to you, because the reds, oranges, yellows, blues, and violets are being absorbed by the stem, while the green wavelengths of light are being reflected off the stem.

How Does the Eye See Color? There are three separate color-sensitive nerve systems in the human eye. One set of nerves is sensitive only to red light; another set is sensitive to blue light; the third set is sensitive to green light. Through a combination of the red-, blue-, and green-sensitive nerve systems, the brain is able to perceive all the colors in the visible spectrum of light. When violet-colored light is reflected from an object to the eye, the blue-sensitive nerve system and the red-sensitive nerve system are stimulated together. Equal amounts of blue and red translate into violet. If the light reflected from this object stimulates the blue-sensitive nerve system more than the red-sensitive nerve system, we perceive the object as being purple or some other bluish-red color. In the same manner, the eye can perceive any color according to the combination of nerve systems being stimulated at any given moment.

Suppose the reflected light from an object stimulates all three nerve systems equally. What happens? The eye (and the brain) perceives the object as white. Surprised? Equal amounts of red, orange, yellow, green, blue, and violet—all mixed together—produce white. By differentiating light into just three colors—red, blue, and green—the human eye enables the mind to interpret and perceive all colors.

How Does Color Film "See" Color? Like the human eye, color film is divided into three light-sensitive layers: red, blue, and green. What happens when a magenta-colored object is photographed? The light reflected from the object affects the blue-sensitive layer and the red-sensitive layer equally. The blue and red light-sensitive layers of the film reproduce the magenta color of the object. When a violet-colored object (bluish-purple) is photographed, light reflected from the object affects the blue-sensitive film layer more and the red-sensitive film layer less. This is because the violet wavelength of light is closer to blue than red. In each case, the light from the violet object did not affect the green-sensitive film layer.

14. **True or False.** Like the human eye, color film is divided into three light-sensitive layers: red, blue, and green.

Answer
14. True

Silver-Halide Crystals. We mentioned earlier that all color films rely on silver-halide crystals to create a black and white image during exposure and development. But silver-halide presents a problem:

12. **True or False.**
Your brain perceives a red rose because red wavelengths of white light are being absorbed by the petals of the rose.

13. **True or False.**
The brain is capable of perceiving light through six separate color-sensitive nerve systems in the human eye.

Answers
12. False. A color is perceived because of reflected light.
13. False. There are only three color-sensitive nerve systems in the human eye.

When silver-halide crystals are exposed to light, they do not turn red, blue, or green when developed. They turn black! Fortunately, this problem has been cleverly solved. (See figure 3-2.)

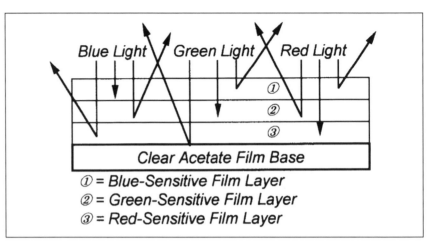

Figure 3-2—Cross section of unexposed color film

There are three color-sensitive layers in color film.

One additional ingredient found in color film that is not found in black and white film is color couplers. These couplers are interspersed among the silver-halide crystals in each of the color-sensitive film layers. There are three color-sensitive layers in color film: blue-sensitive film layer, green-sensitive film layer, and red-sensitive film layer. Red light is absorbed by the red-sensitive film layer and is reflected from the blue-sensitive and green-sensitive film layers. If there are only blue-, green-, and red-sensitive film layers, how does the film handle yellow, magenta, and cyan colors? Okay, let's see what happens when the reflected light from our magenta-colored object strikes the film. By looking at the color wheel color key, you can see that magenta is composed of equal parts of red light and blue light. The magenta-colored light, then, will affect the silver-halide crystals in both the red-sensitive and blue-sensitive layers of the film. It will not affect the silver-halide crystals in the green-sensitive layer. Why? Because no green wavelengths of light are being reflected from the object to the film. The magenta-colored light has no effect on the color couplers because they are not light-sensitive.

After the film has been exposed to the magenta-colored object, the film is placed in color developer. You already know that once exposed film is developed, the silver-halide crystals are converted into black metallic silver. Up to this point, color and black and white film go through the same development process. However, it is at this point that the color couplers take over. The couplers in each layer of the film form a colored dye to exactly the same proportions of the black metallic silver. The production of the dye is coupled to the production of black metallic silver; that is, the more black metallic silver,

15. One ingredient found in color film that is not found in black and white film is _____ _____.

Answer

15. color couplers

the more dense the dye. Conversely, the less black metallic silver, the thinner the dye.

This is where things begin to get a little confusing! You would expect that a red dye would be produced in a red-sensitive layer, a blue dye in a blue-sensitive layer, and a green dye in a green-sensitive layer. The fact is, dyes are produced that are complementary in color to the light-sensitivity of each color-sensitive layer. The colors located opposite one another on the color wheel are complementary colors: yellow is complementary to blue (and vice versa), green is complementary to magenta (and vice versa), and cyan is complementary to red (and vice versa).

Why Complementary Colors? Any color located between any two adjacent colors is produced by a combination of the two adjacent colors (see figure 3-3). Equal proportions of green and blue produce cyan, and the complement of cyan is red (and equal proportions of magenta and yellow produce red). The colors yellow and cyan are listed in parentheses next to the green color key located to the left of the color wheel. This indicates that equal proportions of yellow and cyan produce green. Next to the magenta color key, the colors red and blue are listed in parentheses. This indicates that equal proportions of red and blue produce magenta. Complementary colors are colors opposite each other on the color wheel. Green is the complement of magenta (as indicated by the dotted line with arrows) and magenta is the complement of green.

> Complementary colors are colors opposite each other on the color wheel.

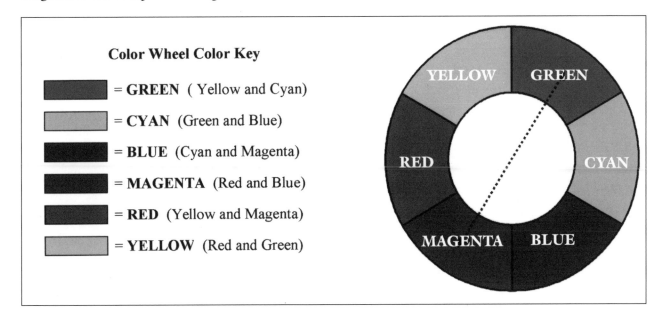

Color Wheel Color Key

- = **GREEN** (Yellow and Cyan)
- = **CYAN** (Green and Blue)
- = **BLUE** (Cyan and Magenta)
- = **MAGENTA** (Red and Blue)
- = **RED** (Yellow and Magenta)
- = **YELLOW** (Red and Green)

Figure 3-3—The color wheel

Black in the negative reproduces as white in the print.

In all color films, the dye in each layer is as follows: red-sensitive layer—cyan dye; blue-sensitive layer—yellow dye; green-sensitive layer—magenta dye. Recall that in a black and white negative, everything is reversed. Black areas in the negative reproduce as white areas in the print; white areas in the negative reproduce as black areas in the print. Likewise, in a color negative everything is also reversed: red is opposite cyan, blue is opposite yellow, and green is opposite magenta.

Suppose we expose a frame of color film to a magenta-colored object. What happens? In order to reproduce the magenta color, there has to be an equal buildup of black metallic silver in the blue-sensitive layer of the film and in the red-sensitive layer of the film. The complement of red is cyan and the complement of blue is yellow; therefore, there is an equal buildup of cyan dye in the red-sensitive layer and yellow dye in the blue-sensitive layer. When cyan and yellow are mixed together the result is green. What is the complement of green? Magenta!

If you hold a color negative up to a source of bright light immediately after its development stage, you wouldn't see any colors. The black metallic silver would be blocking them out. Color film processing requires that the black metallic silver be removed or washed away, leaving the color dyes on the negative. (In black and white film processing, the unexposed silver-halide crystals are washed away, but the black metallic silver remains on the film base.) After the black metallic silver has been removed from the color film base, the color dyes that remain can be clearly seen.

Color Corrections. You will be primarily concerned with the finished print. In the "Color Characteristics" section of this lesson, you learned how to examine an image for color balance. Color balance includes accurate color reproduction and color casts. Now it is time for you to learn how to correct inaccurate color reproductions and eliminate color casts.

Note: Refer to the color wheel when answering the following questions.

16. A frame of color film is exposed to a cyan-colored object. In order to produce the cyan color, there is an equal buildup of black metallic silver in the _____-sensitive layer and _____-sensitive layer of the film.
17. The complement of the _____-sensitive layer is _____.
18. The complement of the _____-sensitive layer is _____.
19. When the complementary colors of _____ and _____ are mixed together the result is _____.
20. The complement or opposite of _____ is _____.

Answers
16. blue, green
17. blue, yellow (or green, magenta)
18. green, magenta (or blue, yellow)
19. yellow, magenta, red
20. red, cyan

Correcting Inaccurate Color Reproductions. You're viewing a print of a model and you determine that her skin tones aren't quite correct. What can you do to improve the image? Simply view the print through viewing filters until you see an improvement in the model's skin tones. What are viewing filters? Viewing filters usually consist of colored gelatin acetate mounted on cards. There are six cards to a set of viewing filters, and each card contains three filters of different shades of red, blue, green, cyan, yellow, and magenta. Kodak markets a Color Print Viewing Filter Kit and distributes it through camera stores, photo supply houses, and other photography-related retail outlets. The kit can also be purchased directly from Kodak. (For Kodak's mailing address, refer to appendix B.)

Let's suppose you determine the best color rendition for the skin tones is viewed through the yellow filter. The viewing filter you are using contains three different shades, or intensities, of yellow: 10Y, 20Y, and 40Y. View the print again through each of the different yellow shades. When you find the particular shade of yellow that gives the model the most pleasing skin tone, you will know how much yellow filtration must be added to the print to reproduce a more accurate skin tone color. Suppose the 20Y filter gave the best skin tone rendition. Mark this on the back of the print and give it to the darkroom technician. The technician will make another print from the negative using a 20Y filter.

You can use the Kodak Color Print Viewing Filter Kit to correct individual colors or skin tones of a subject within a print, but you must be aware that other colors in the print will also be affected. Therefore, you must determine whether it is important enough to alter the color tone of one element within the print at the expense of the other elements. Of course, using a 20Y filter to improve the model's skin tones might create a slightly yellowish color cast across the entire print. When working with color-correcting filters to improve the color rendition in a specific part of the print, always examine the print carefully for unwanted color shifts elsewhere.

Suppose, instead of poor skin tones, the original print had an overall yellowish cast. In this case, you could exercise one of two options: use the Kodak filter kit to determine which filter (or which combination of filters) is required to remove the color cast, or instruct the darkroom technician to do the following:

- To eliminate a yellow color cast, de-emphasize yellow or increase magenta and cyan. (If you view the print through a magenta filter, you will see a noticeable decrease in the yellow cast; if you view the print through a cyan filter, you will also see a noticeable decrease in the

. . .always examine the print carefully for unwanted color shifts. . .

yellow cast. However, by viewing the print through a combination of magenta and cyan filters, the yellow cast virtually disappears.)

- To eliminate a magenta color cast, de-emphasize magenta or increase yellow and cyan. (If you view the print through a yellow filter, you will see a noticeable decrease in the magenta cast; if you view the print through a cyan filter, you will see the same noticeable decrease in the magenta cast. However, by viewing the print through a combination of yellow and cyan filters, the magenta cast virtually disappears.)
- To eliminate a cyan color cast, de-emphasize cyan or increase yellow and magenta. (If you view the print through a yellow filter, you will see a noticeable decrease in the cyan cast; if you view the print through a magenta filter, you will see the same noticeable decrease in the cyan cast. However, by viewing the print through a combination of yellow and magenta filters, the cyan cast virtually disappears.)

What happens if there is more than one color cast?

What happens if there is more than one color cast? For example, too much yellow and magenta (reddish cast), too much magenta and cyan (bluish cast), or too much yellow and cyan (greenish cast)? Instruct the darkroom technician to do the following:

- To eliminate a reddish color cast, de-emphasize yellow and magenta or increase cyan.
- To eliminate a bluish color cast, de-emphasize magenta and cyan or increase yellow.
- To eliminate a greenish color cast, de-emphasize yellow and cyan or increase magenta.

● Section Self-Test #3

Use a separate sheet of paper to write down your responses to the following questions. Check your responses against the answers provided in appendix A.

1. All color films rely on _____ to create a black and white image during exposure and development.
 a. Black metallic silver
 b. Silver-halide crystals
 c. Color couplers
2. We perceive a rose as being red because:
 a. The rose absorbs the red wavelengths of light

 b. The red wavelengths of light are reflected off the rose

 c. The rose absorbs the green wavelengths of light

3. There are three separate color-sensitive nerve systems in the human eye. They are the:

 a. Magenta-, cyan-, and yellow-sensitive nerve systems

 b. Red-, cyan-, and blue-sensitive nerve systems

 c. Red-, blue-, and green-sensitive nerve systems

4. When violet-colored light (magenta) is reflected from an object to the eye, which color-sensitive nerve system(s) is/are stimulated?

 a. Blue-sensitive nerve system

 b. Green- and blue-sensitive nerve systems

 c. Red- and blue-sensitive nerve systems

5. Like the eye, color film is divided into three light-sensitive layers. The layers are:

 a. Magenta, cyan, and yellow

 b. Magenta, blue, and green

 c. Red, blue, and green

6. When a cyan-colored object is photographed, light reflected from the object affects the:

 a. Green- and red-sensitive film layers

 b. Blue- and red-sensitive film layers

 c. Green- and blue-sensitive film layers

7. One additional ingredient found in color film that is not found in black and white film is:

 a. Silver-halide crystals

 b. Black metallic silver

 c. Color couplers

8. The red-, blue-, and green-sensitive film layers produce dyes that are complementary to the light-sensitivity of each color-sensitive layer. These complementary colors are:

 a. White, black, and gray

 b. Gray, yellow, and violet

 c. Cyan, magenta, and yellow

9. The Kodak Color Print Viewing Filter Kit can be used for:

 a. Correcting inaccurate color reproductions

 b. Changing colors in the print

 c. Converting color images to black and white images

10. To eliminate a reddish color cast from a print, you would give the darkroom technician the following instructions:

 a. De-emphasize magenta and cyan or increase yellow

 b. De-emphasize yellow and magenta or increase cyan

 c. De-emphasize yellow and cyan or increase magenta

There are three separate color-sensitive nerve systems in the human eye.

● Understanding Exposure Control

Exposure refers to the amount of light that enters the lens of a camera and strikes the film plane. There must be some way to control this flow of light to regulate the amount of exposure the film receives. This control is called an *aperture*. The aperture is located inside the lens of the camera and acts like a water faucet. The more it is opened, the more light that strikes the film plane; the more it is closed, the less light that strikes the film plane. The important concept to keep in mind is that the size of the aperture opening is directly related to the f/stop number. Figure 3-4 (from left to right) illustrates aperture openings at f/2, f/8, and f/16, respectively.

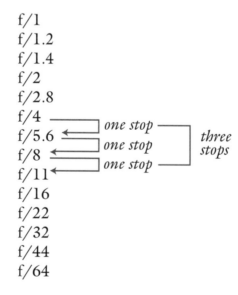

Figure 3-4—Aperture openings at different f/stops

What Are F/Stops, and How Do They Relate to Exposure Control? A number indicates the size of the aperture. This number is called an *f/stop*. The *smaller* the f/stop number, the *larger* the aperture opening. The full sequence of f/stop numbers (from largest aperture opening to smallest aperture opening) is as follows:

f/1
f/1.2
f/1.4
f/2
f/2.8
f/4
f/5.6
f/8
f/11
f/16
f/22
f/32
f/44
f/64

Figure 3-5—F/stops (from largest aperture opening to smallest)

21. **True or False.**
 Exposure refers to the amount of light that enters the lens of a camera and strikes the film plane.

22. **True or False**.
 Exposure control refers to the ability to regulate the amount of light the film receives.

23. **True or False**.
 The control used to regulate the amount of exposure the film receives is called a shutter.

Answers

21. True

22. True

23. False. The control is called an aperture.

Theoretically, f/stop numbers can get larger than f/64; realistically, however, most 35mm and medium-format camera lenses contain f/stop numbers from f/1.4 to f/22. The important thing to remember about f/stop numbers is to think opposites: As f/stop numbers get larger, aperture openings get smaller; as the f/stop numbers get smaller, aperture openings get larger. In other words, f/4 is a larger opening than f/16. If the aperture of the lens is positioned at f/8, and you reposition it to f/4, you would be opening up the aperture. If you reposition the aperture to f/16, you would be closing, or *stopping down* the aperture. Here are two very simple but very important concepts: Opening up one full f/stop *doubles* the amount of light entering the lens of the camera and striking the film plane; closing down one full f/stop cuts the amount of light entering the lens of the camera in *half*.

Therefore, f/4 admits twice the amount of light as f/5.6 and four times the amount of light as f/8. Conversely, f/5.6 admits only one-half the amount of light as f/4 and one-quarter the amount of light as f/2.8. Do you understand why? Let's say a photographer adjusted his or her f/stop from f/4 to f/11 (the aperture is being closed down and less light is being admitted into the lens of the camera). There is a difference of three f/stops between f/4 and f/11, as shown in figure 3.5. For every one full f/stop the aperture is closed down, the amount of light entering the lens is being cut in half. There are three f/stops between f/4 and f/11, therefore only $\frac{1}{8}$ the amount of light ($\frac{1}{2}$ x $\frac{1}{2}$ x $\frac{1}{2}$ = $\frac{1}{8}$) is entering the lens and striking the film plane. If the aperture was being opened up from f/11 to f/4, then eight times the amount of light (2 x 2 x 2 = 8) would enter the lens and strike the film plane, because for every one full f/stop the aperture is opened up, the amount of light entering the lens is doubled.

Refer to photographs 3-1 through 3-6. Photograph 3-1 represents the widest aperture opening (f/2.8) of the six identical photographs. With each photograph that follows photograph 3-1, the aperture was closed down by one additional f/stop, reducing the light source (exposure) by one-half for each additional f/stop setting. The six identical photographs illustrate the concept of *exposure control* through various f/stop settings. The photographs were taken at the same shutter speeds, and using the same type of film.

- Photograph 3-2 was exposed at f/4 and represents $\frac{1}{2}$ the exposure of photograph 3-1.
- Photograph 3-3 was exposed at f/5.6 and represents $\frac{1}{4}$ the exposure of photograph 3-1 ($\frac{1}{2}$ x $\frac{1}{2}$ = $\frac{1}{4}$).
- Photograph 3-4 was exposed at f/8 and represents $\frac{1}{8}$ the

As f/stop numbers get larger, aperture openings get smaller.

24. The important thing to remember about f/stop numbers is to think _____.

25. As f/stop numbers get larger, aperture openings get _____; as f/stop numbers get smaller, aperture openings get _____.

26. Opening up one full f/stop _____ the amount of light entering the lens of the camera and striking the _____ plane; closing down one full f/stop cuts the amount of light in _____.

Answers

24. opposites

25. smaller, larger

26. doubles, film, half

The Effect of Different Aperture Settings

Original Photo by June Jacobson

Photograph 3-1—Aperture set at f/2.8

Photograph 3-2—Aperture set at f/4

Photograph 3-3—Aperture set at f/5.6

Photograph 3-4—Aperture set at f/8

Photograph 3-5—Aperture set at f/11

Photograph 3-6—Aperture set at f/16

exposure of photograph 3-1 ($\frac{1}{2}$ x $\frac{1}{2}$ x $\frac{1}{2}$ = $\frac{1}{8}$).

- Photograph 3-5 was exposed at f/11 and represents $\frac{1}{16}$ the exposure of photograph 3-1 ($\frac{1}{2}$ x $\frac{1}{2}$ x $\frac{1}{2}$ x $\frac{1}{2}$ = $\frac{1}{16}$).
- Photograph 3-6 was exposed at f/16 and represents $\frac{1}{32}$ the exposure of photograph 3-1 ($\frac{1}{2}$ x $\frac{1}{2}$ x $\frac{1}{2}$ x $\frac{1}{2}$ x $\frac{1}{2}$ = $\frac{1}{32}$).

Photograph 3-6 represents the smallest aperture opening of the six identical photographs. Can you tell which photograph has been exposed at the correct f/stop?

● Section Self-Test #4

Use a separate sheet of paper to write down your responses to the following questions. Check your responses against the answers provided in appendix A.

1. *True or False.* Exposure refers to the amount of light that enters the lens of the camera and strikes the film plane.
2. The amount of light that enters the lens of the camera and strikes the film plane is controlled by the _____.
 a. shutter
 b. aperture
 c. photographer
3. The smaller the f/stop number, the _____ the aperture opening; the larger the f/stop number, the _____ the aperture opening.
 a. larger, smaller
 b. smaller, larger
4. Opening the aperture up one full f/stop _____ the amount of light entering the lens of the camera; closing down the aperture one full f/stop _____ the amount of light.
 a. doubles, halves
 b. halves, doubles
5. A photographer adjusts his or her aperture from f/8 to f/4. That's a difference of _____ f/stops. How much more or less light is entering the lens of the camera?
 a. three, twice as much light
 b. two, four times as much light
 c. two, $\frac{1}{8}$ as much light
6. A photographer adjusts his or her aperture from f/4 to f/11. That's a difference of _____ f/stops. How much more or less light is entering the lens of the camera?
 a. three, $\frac{1}{8}$ as much light

How much more or less light is entering the lens of the camera?

b. two, four times as much light

c. two, eight times as much light

7. Refer to photographs 3-1 through 3-6. Which photograph do you think is the one that is properly exposed?

a. Photograph 3-1 exposed at f/2.8

b. Photograph 3-2 exposed at f/4

c. Photograph 3-3 exposed at f/5.6

d. Photograph 3-4 exposed at f/8

e. Photograph 3-5 exposed at f/11

f. Photograph 3-6 exposed at f/16

8. Do you understand the concept of f/stop numbers and how they relate to exposure control?

a. Yes! Proceed to the next section, "The Zone System."

b. No! Review "Understanding Exposure Control."

● The Zone System

Some photographers love to make mountains out of molehills! The Zone System is the perfect example. It has been the subject of many books and articles, and the topic of endless controversy wherever photographers gather together to discuss their craft. This lesson on the Zone System applies primarily to black and white photography. However, the same principles apply to color photography.

Some professional photographers with overgrown egos have elevated the Zone System to mystical and magical proportions, convincing amateur photographers that the Zone System is not only difficult to master, but is better left to photographers who have had years of experience. In fact, as you will learn in this section, the Zone System is a very simple tool that photographers use to determine correct exposure and can be mastered by all within a short period of time. An understanding of the Zone System will aid you in editing and evaluating photographs for proper exposure, and in determining if a particular image should be used for publication purposes.

Before we begin this lesson on the Zone System, it should be pointed out that the Zone System is a very valuable tool if—like Ansel Adams—you use it with large-format, sheet-film cameras. Its application in both 35mm and medium-format photography is more limited. The reason for this is because, with sheet film, each negative can be individually controlled during exposure (in the camera) and development (in the darkroom). In 35mm or medium-format photography, each exposure on the roll of film cannot be individually controlled during development. The photographer can control the amount of exposure that each frame of film receives in the camera, but the entire roll of film is subjected to the same development. In other words, each negative can't be developed apart from the others.

Some photographers love to make mountains out of molehills!

27. **True or False.**
The Zone System can be used to individually control each exposure on a 35mm roll of film during development.

Answer

27. False. Only large-format sheet film can be individually controlled during development because, unlike roll film, each sheet can be developed into a negative one frame at a time.

Therefore, application of the Zone System in 35mm and medium-format photography is limited to exposure of the film in the camera.

In a nutshell, the Zone System allows the photographer to record the differences in the range of brightness in the scene or on the object that is being photographed. At this point you might ask the question: Isn't the camera's exposure meter performing the same function? The answer is—not really! The exposure meter will give the photographer an averaged exposure reading of all the light in the scene. For example, if the photographer relies solely on the camera's meter to record a scene that contains a lot of dark and light areas, such as a black cat walking across a snow-covered meadow, the meter will average the dark and light areas in the scene to give the photographer a gray value. The result will be a dark gray cat walking across a light gray snow-covered meadow.

Zone	Description and Examples
Zone 10	**Pure White** No detail. Snow in bright sunlight. Referred to as key white.
Zone 9	**Almost Pure White** Very light gray. Glaring surfaces like snow in flat light or sunlight on a white wall. Slightest hint of texture.
Zone 8	**Whitish Gray** Between pale "white" skin and sunlight on a white wall. Highlight details still distinguishable.
Zone 7	**Light Gray** Pale "white" skin. A sidewalk in sunlight. Light fabrics with visible texture.
Zone 6	**Light Middle Gray** Average "white" skin with no highlight on it. The shadow in snow in a bright sunlit scene.
Zone 5	**Middle Gray (18% gray)** Dark-toned "white" skin. Light-toned "black" skin. Weathered wood. Light foliage. The darkest blue of a clear sky.
Zone 4	**Darkish Gray** Dark-toned "black" skin. Dark foliage. Shadows in landscapes or buildings.
Zone 3	**Blackish Gray** Textured shadows. Details and textures are clearly visible in "blacks," such as dark fabrics.
Zone 2	**Grayish Black** A hint of texture in photograph.
Zone 1	**Nearly Pure Black** Very Dark Gray. Details barely distinguishable.
Zone 0	**Pure Black** No detail. Referred to as key black.

Figure 3-6—Zone System table

28. **True or False.**
 The camera's exposure system performs the same function and yields the same exposure values as the Zone System.
29. The Zone System is divided into _____ zones: Zone 0 is pure _____ and Zone 10 is pure _____, with each gray tone between Zone 1 and Zone 9 getting progressively _____.

Answers
28. False
29. eleven, black, white, lighter

ZONE 10
Pure White

ZONE 9
Almost Pure White

ZONE 8
Whitish Gray

ZONE 7
Light Gray

ZONE 6
Light Middle Gray

ZONE 5
Middle Gray

ZONE 4
Darkish Gray

ZONE 3
Blackish Gray

ZONE 2
Grayish Black

ZONE 1
Nearly Pure Black

ZONE 0
Pure Black

Figure 3-7—Zone System gray scale

There are several variations on the Zone System gray scale, but generally the Zone System (figures 3-6 and 3-7) is divided into eleven zones ranging from pure black to pure white. Pure black is called Zone 0 and pure white is called Zone 10, with each gray zone above Zone 0 getting progressively lighter.

Between Zones 0 and 10, there are nine zones of gray values, with each shade of gray getting progressively lighter from Zone 1 through Zone 9. The middle zone—Zone 5—is the zone from which all exposure calculations are determined. Why Zone 5? Because Zone 5 represents the gray value at which all light meters and gray cards are calibrated. Some astute amateur photographers have raised an interesting question: If Zone 5 represents middle gray, then why is it called 18% gray and not 50% gray? Physicists who study the properties of light have determined that all natural light, on average, contains about 18% gray tone. When the Zone System was devised by Ansel Adams, he set up his gray scale so Zone 5 (middle gray) would represent average (18% gray) light, with all other exposure calculations being added to or subtracted from this middle zone.

30. **True or False.** The middle zone—Zone 5—represents middle gray or 50% gray.
31. **True or False.** All exposure calculations are based upon Zone 5.

Answers

30. False. Zone 5, or middle gray, represents 18% gray.
31. True

Exposure Meters Are Calibrated to Zone 5. Exposure meters are calibrated to Zone 5—no matter what the actual tone of the subject or the scene may be. From this starting point, each zone above or below Zone 5 represents a difference of one f/stop. Therefore, exposing the subject or scene to Zone 4 represents one f/stop less than the actual meter reading; Zone 3 represents a difference of two f/stops less than the actual meter reading. Inversely, Zone 6 represents one f/stop more than the actual meter reading and Zone 7 represents two f/stops more than the actual meter reading. The eleven zones in the Zone System represent a difference of ten f/stops—from Zone 0 to Zone 10. Why only ten f/stops? Because the ten-f/stop range is enough to cover all the light values in any given exposure from the darkest blacks to the very brightest highlights.

32. Exposure meters are calculated to Zone _____.
33. Zone 8 represents (how many?) _____ f/stops (more/less) than the actual meter reading.
34. Zone 2 represents (how many?) _____ f/stops (more/less) than the actual meter reading.

Answers

32. five

33. three, more

34. three, less

The Zone System and Exposure Compensation. How do you use the Zone System for determining perfect exposures? The Zone System gives the photographer the ability to visualize approximately how he or she wants the finished print to look. Then, through exposure of the film in the camera and development of the print in the darkroom, a print is produced with the same look. Ansel Adams compared the tonal values of each zone to specific common objects and noted that average caucasian skin typically reproduced as Zone 6 gray—not Zone 5. Recall that Zone 5 represents an average exposure. Refer to the Zone System table to see how each zone relates to common objects as observed by Ansel Adams. Working with large-format sheet film, such as 4" x 5" and 8" x 10" negatives, Ansel Adams was able to render each zone with a specific tonal quality. He accomplished this by utilizing the Zone System in two ways. First, he used the Zone System to establish perfect exposures. (This will be explained more fully as you progress through this lesson.) Second, he used the Zone System to establish the precise development time required for each sheet of film.

Using the Zone System for establishing the precise development time when developing 35mm and medium-format roll film isn't practical, because each frame on the roll will have been exposed with different shutter speeds and f/stops; the entire roll of twenty-four or thirty-six images are developed together, rather than as single frames that can be developed individually as with sheet film. It is possible to develop roll film using the Zone System, but the entire roll of film must be exposed with the same shutter speed and at the same f/stop, allowing identical development for each and every negative.

Examples of Applying the Zone System. *Example #1:* A photographer is shooting an outdoor portrait of a woman who has average caucasian skin. ("Average" here refers to light skin with some brown tone, such as a light suntan as opposed to milk-white skin or dark brown skin.) A meter reading of her facial tones yields an expo-

How do you use the Zone System for determining perfect exposures?

sure of f/8 at ¹⁄₁₂₅ second. The meter is averaging the light for Zone 5. But average "light" skin falls into Zone 6 (see figure 3-6). The difference between Zone 5 and Zone 6 is one zone—or one f/stop. What should the photographer do? He or she should compensate for the one f/stop of difference. But should the photographer open up by one f/stop or close down by one f/stop? Here's a simple way to remember whether to open up or close down the aperture of the lens: Moving up the scale, open up the aperture; moving down the scale, close down the aperture.

The exposure recorded by the meter in example #1 is f/8. The photographer knows this is a Zone 5 exposure reading. Average "light" skin falls into Zone 6. Zone 6 is up the scale from Zone 5 by one zone, therefore the photographer would open up the aperture of the lens by one f/stop to f/5.6, maintaining the same shutter speed. What have you learned from this example? The light meter recorded an exposure of f/8 at ¹⁄₁₂₅ second. But the proper exposure, according to the Zone System, is f/5.6 at ¹⁄₁₂₅ second. If the photograph is taken according to the light meter reading, the exposure will be a full f/stop off.

Example #2: A photographer is shooting an outdoor portrait of a man who has dark-toned skin. A meter reading of his facial tones yields an exposure of f/5.6 at ¹⁄₆₀ second. According to the Zone System, dark-toned skin falls into Zone 4. The meter is averaging the light for Zone 5. Zone 4 is down the scale from Zone 5 by one zone, therefore, the photographer would close down the aperture of the lens by one f/stop to f/8, maintaining the same shutter speed.

Example #3: A photographer is shooting a full-length photograph of a blond model in a bathing suit. The model has pale skin. A meter reading of her skin tones yields an exposure of f/11 at ¹⁄₂₅₀ second. The Zone System places pale skin in Zone 7. Since Zone 7 is up the scale from Zone 5 by two zones, the photographer would open up the aperture of the lens by two f/stops to f/5.6, maintaining the same shutter speed.

Example #4: A photographer wants to photograph a brilliantly sunlit field of snow. By now, you should be starting to appreciate that a light meter—calibrated to Zone 5—simply can't handle this type of situation. The meter "sees" a vast area of bright highlights and indicates an exposure of f/16 at ¹⁄₅₀₀ second. If the meter could talk, it would say, "Yikes! I'm being blinded! Shut down to f/16!" If the photographer shoots at this exposure, the field of brilliant white snow will look 18% gray in the finished print. Snow in bright sunlight falls into Zone 10. Because Zone 10 is up the scale from Zone 5 by five zones, the photographer would open up the aperture of the lens by five f/stops to f/2.8, maintaining the same shutter speed.

If the meter could talk, it would say, "Yikes! I'm being blinded!"

Example #5: A photographer wants to shoot a photograph of a black cat sitting in a field of white snow. The black cat falls into Zone 1. (Why Zone 1 and not in Zone 0? Because some detail can probably be seen on the cat, such as shadow areas and hair texture—a quality of Zone 1. Zone 0, however, is pure black and contains no visible detail.) The light meter indicates an exposure of f/2.8 at $\frac{1}{125}$ second. Zone 1 is down the scale from Zone 5 by four zones, therefore, the photographer would close down the aperture of the lens by four f/stops to f/11, maintaining the same shutter speed.

The Importance of Visualizing. What is visualizing? Visualizing is observing the various tones in a scene and imagining how you want these tones to reproduce in the final print. Visualizing also refers to composing or setting up the elements within the viewfinder of the camera for the purpose of producing an artistically pleasing image. However, when working with the Zone System, the photographer is particularly interested in the tonal values of the scene.

Visualizing, then, means looking at a field of snow (as in example #4) and knowing that it should reproduce as pure white (Zone 10), or looking at a black cat (as in example #5) and knowing that it should reproduce as Zone 1 black. In a portrait, the skin tone is usually the most important factor. Therefore, when editing and evaluating portraits of people, pay particular attention to skin tones and not peripheral objects within the photographic frame.

The Photographer and the Zone System. How does an understanding of the Zone System benefit the photographer? Imagine you are a photo editor and you receive a photograph from a photographer for publication consideration. Imagine the photo is a portrait of a very old woman sitting in a rocking chair. By carefully evaluating this photo, you would be able to determine whether the photographer had properly exposed the image to the Zone System or simply relied upon the camera's built-in metering system. If the scene or subject required an average exposure—a Zone 5 exposure—the built-in meter will do the job. However, most scenes or subjects require compensatory adjustments for perfect exposures.

In this particular photo of the old woman, you note that something is wrong with the exposure. The old woman in the rocking chair is wearing a white blouse, but the tones in the blouse are light gray. You observe the woman's face, which also contains some light gray tones, and reasonably surmise that at her age, her skin tones are probably more white than the image portrays. Obviously, the photographer relied on the built-in light meter of the camera for determining the exposure value at which he or she shot the photograph. The photo was shot at an average exposure—a Zone 5 exposure. The photograph might be good at that exposure, however, and as the

In a portrait, the skin tone is usually the most important factor.

35. **True or False.**
Visualizing, with respect to the Zone System, means imagining how you want the tones in a particular scene to reproduce in the final print.

Answer
35. True

photo editor, you might decide to use it as is. But, had the photograph been shot at the correct exposure, the image would have been greatly improved. Try to determine at which zone the photographer should have compensated his or her exposure of the old woman. If the photographer had originally exposed the photograph at f/8, to what f/stop setting should the photographer have adjusted the aperture of the lens for a perfect exposure?

Stop Here! See if you can determine the correct zone and exposure value from figure 3-6 (Zone System table), before reading any further.

Let's see how well you did. You know the blouse should have been white—not light gray. You also know the woman's face contained the same light gray tones as the blouse, therefore, her facial tones must be white, too. As you viewed the exposure values in the Zone System table, you should have noticed that the light gray tones fall into Zones 6 and 7. Zone 6 is for average caucasian skin. Because the woman is old, it would be reasonable to assume that her skin tone would not be average; Zone 7 is for pale white skin, the skin tone you would expect to find on a very old woman. Zone 7, therefore, is the zone at which the photographer should have compensated his or her exposure value. Zone 7 is two zones—or two f/stops—more than Zone 5. The photographer exposed the image at f/8. The corrected exposure is two f/stops up the scale; therefore, the photographer should have opened up the aperture on the lens to f/4. Do you now see how an understanding of the Zone System can aid the photographer in editing and evaluating photographic images?

Example of a Photograph Exposed to the Zone System. Compare photograph 3-7 to the Zone System gray scale on the right. Carefully examine how the photographer used the Zone System to achieve the perfect exposure. It was mentioned earlier that a perfectly exposed black and white photograph would include areas of pure white, pure black, and a good range of gray tones in between. The exposure of this photo was achieved through the use of the Zone System. The kitten in this image contains pure white, especially around the highlighted areas (those areas that are backlighted by bright sunlight) and pure black in the shadow areas. Between these two extremes are found various gray tones from light grays to medium grays to dark grays. Even the log the kitten has been placed in contains pure black and a good range of gray tones. The only reason why there is no pure white around the log is because there are no pure white areas to be photographed. Notice how rich the black area is directly behind the kitten. This photograph wouldn't have the same impact if this area were dark gray. The exposure of this image is such that every little detail of the kitten and the log is clearly visible.

Notice how rich the black area is directly behind the kitten.

Do you think this was an average—Zone 5—metered shot? Absolutely not! A Zone 5 shot would have averaged the blacks and whites in this image, and the kitten's highlighted areas near its ear and at the top of its head would have photographed as light gray. Likewise, the rich black areas behind the kitten and in the lower left corner of the photographic frame would have photographed as dark gray. Using the Zone System gray scale, compare each of the zones on the scale to the photograph of the kitten in the log. By carefully observing the range of gray tones in the photograph, you will begin to appreciate images that have been exposed according to the Zone System.

Photograph 3-7—Kitten Asleep in a Log
(Photo by June Jacobson)

ZONE 10 Pure White
ZONE 9 Almost Pure White
ZONE 8 Whitish Gray
ZONE 7 Light Gray
ZONE 6 Light Middle Gray
ZONE 5 Middle Gray
ZONE 4 Darkish Gray
ZONE 3 Blackish Gray
ZONE 2 Grayish Black
ZONE 1 Nearly Pure Black
ZONE 0 Pure Black

36. **True or False.** A perfectly exposed black and white photograph will contain areas of pure black, pure white, and various shades of gray tones in between.

Answer

36. True. Some scenes may not contain dark shadows or bright highlights and, therefore, pure black or pure white areas may not appear in the photograph; however, all black and white photographs should contain various shades of gray.

● Section Self-Test #5

Use a separate sheet of paper to write down your responses to the following questions. Check your responses against the answers provided in Appendix A.

1. *True or False.* An understanding of the Zone System will help you in evaluating and editing photographs for proper exposure.

2. *True or False.* In 35mm and medium-format photography, application of the Zone System permits total exposure control during development of the film.

3. *True or False.* A camera's exposure meter will give the photographer a perfect exposure reading, if used properly.

4. The Zone System is divided into _____ zones, ranging from Zone 0 or _____ _____ to Zone 10 or _____ _____.

 a. ten, pure black, pure white
 b. eleven, pure black, pure white
 c. eleven, pure white, pure black

5. Zone _____ is the zone from which all exposure calculations are determined. This zone is also referred to as _____ _____.

 a. seven, average gray
 b. five, middle gray
 c. three, 18% gray

6. Exposing a scene to Zone 4 represents _____ f/stop(s) _____ than the actual meter reading.

 a. two, more
 b. one, more
 c. one, less

7. Exposing a scene to Zone 8 represents _____ f/stops(s) _____ than the actual meter reading.

 a. three, more
 b. four, more
 c. three, less

8. A photographer is attempting to photograph textured shadows on a dark fabric. A meter reading yields an exposure value of f/5.6. In which zone should the photographer shoot the photograph? (See Zone System table.)

 a. Zone 2
 b. Zone 3
 c. Zone 4

A photographer is attempting to photograph textured shadows. . .

9. To what exposure value should the photographer adjust the camera's aperture (according to your answer in question 8)?
 a. f/2.8
 b. f/5.6
 c. f/11

10. When working with the Zone System, visualizing is:
 a. Composing or setting up the elements within the viewfinder of the camera for the purpose of producing an artistically pleasing image.
 b. Observing the tones in a scene and imagining how you want these tones to reproduce in the final print.
 c. Using the principle of thirds to create patterns, balance, and order within the photographic frame.

11. A photographer submits a photograph to you of three young black children romping in and out of the spray of an open fire hydrant. The skin of the children is so dark you can hardly see any skin tone details. Where do you think the photographer went wrong in exposing this image?
 a. The photographer exposed the image at a Zone 5 exposure (average exposure).
 b. The photographer was probably shooting in areas with dark shadows and couldn't get enough light for proper exposure.
 c. The photographer was probably shooting under bright lighting conditions and overexposed the film by one or two f/stops.

12. What should the photographer have done to achieve a better exposure (according to your answer in question 11)?
 a. The photographer should have exposed the image at a Zone 4 exposure (the recommended exposure for dark-toned skin).
 b. The photographer should have opened up the lens by one full f/stop.
 c. The photographer should have checked the camera's exposure meter to ensure an overexposure condition didn't exist.

What should the photographer have done to achieve a better exposure?

● Hocus Focus!

How can you tell the difference between soft-focus images, selective-focus images, out of focus images, and images that have been blurred by camera shake? There are things you can look for in the photograph to help you determine the difference. Is it important? It could be! A soft-focus portrait of a beautiful woman is quite different than an out of focus image.

In a sharp-focus image, everything within the photographic frame appears sharp: the foreground, the subject, and the background. I have included a sharp-focus photograph for comparative purposes (see photograph 3-8). Use it as the standard by which to compare the soft-focus, selective-focus, and out of focus examples that follow, including the photograph that has been blurred because of camera shake.

Photograph 3-8—Example of sharp-focus image (top, left)

Photograph 3-9—Example of a soft-focus image (top, center)

Photograph 3-10—Example of selective-focus image (top, right)

Photograph 3-11—Example of out of focus image (bottom, left)

Photograph 3-12—Example of camera shake (bottom, right)

A deliberately composed soft-focus photograph is not the same as an out of focus photograph. Soft-focus images are usually created to give a feeling of fragility or to project a delicate image. Portraits of women are usually soft-focus images. With older women, a soft-focus image masks wrinkles and age lines. A soft-focus photograph can also project a dreamlike image. Compare the soft-focus photograph of the woman in photograph 3-9 to the sharp-focus image of the woman in photograph 3-8. Note the subtle differences in focus.

How do you tell the difference between a soft-focus image and an out of focus image? In a soft-focus image everything is within *acceptable* focus. Even though the image is soft (not as sharp as it could be), the focusing is perfectly acceptable to the eye. Notice how the image of the woman in photograph 3-9 is not as sharp as the image of the woman in photograph 3-8, but the image in photograph 3-9 is still within acceptable focus.

You have already learned about selective focusing (refer to lesson 2, "Patterns, Balance, and Order," and the section entitled "Subject Emphasis through Selective Focusing"). In selective-focus photographs, the main subject is normally in sharp focus while everything else around the subject is out of focus. Photograph 3-10 is an example of a selective-focus photograph.

In an out of focus image, something is usually in sharp focus. Almost without exception, the main subject will be out of focus, while other elements in the photograph are in sharp focus (just the reverse of selective focus). In photograph 3-11, the main subject (the woman) is fuzzy or out of focus, while the background is in sharp focus. The photographer simply failed to focus properly.

When camera shake has occurred, everything in the photograph is fuzzy or out of focus. Nothing is sharp. That's how you can normally differentiate between camera shake and out of focus images: If something in the image is sharp, then focus is the problem; if nothing in the image is sharp, then camera shake is the problem. Camera shake occurs when the photographer shoots at slow shutter speeds and fails to hold the camera steady, or when the photographer presses the shutter button with too much force and moves the lens of the camera at the moment of exposure. Photograph 3-12 is an example of camera shake.

In a soft-focus image everything is within acceptable focus.

● Section Self-Test #6

Use a separate sheet of paper to write down your responses to the following questions. Check your responses against the answers provided in appendix A.

1. *True or False.* In a soft-focus photograph, the image is usually created to give a feeling of fragility, or to project a delicate image.
2. *True or False.* The difference between a soft-focus image and an out of focus image is that in a soft-focus image, everything is within acceptable focus.
3. *True or False.* In a selective-focus photograph, the main subject is normally in sharp focus, while everything else around the subject is out of focus.

73

4. *True or False.* In an out of focus image, something within the photograph is usually in sharp focus.

5. *True or False.* When camera shake has occurred, the background is usually out of focus.

. . .something within the photograph is usually in sharp focus.

● **Lesson Summary**

Before continuing on to lesson 4, "The Perfect Photograph," make sure that you have learned all about the concepts of colors, tones, and exposure within the photographic frame. You should now have a thorough understanding of the following concepts, and you should know how to apply these concepts to photographic images for the purpose of selecting and evaluating photographs for publication:

- Color characteristics
- Color saturation
- Color balance
- Color fidelity
- Color contrast
- Black and white exposure
- Development of negatives
- Silver-halide crystals
- Black metallic silver
- Color exposure
- Color theory
- Color couplers
- Complementary colors
- Color correction
- Exposure control
- The Zone System
- Middle gray
- Exposure compensation
- Soft-focus image
- Selective-focus image
- Out of focus image
- Camera shake

LESSON 4

The Perfect Photograph

● Introduction

In this lesson, you will learn: which qualities go into the perfect photograph; the characteristics of good black and white prints; the characteristics of good color prints; the importance of universal themes; what to look for in negatives and transparencies; the difference between commercial and custom processing; the pros and cons between Cibachrome and internegative reproductions; how to effectively crop photographs for visual impact, and how to repair minor blemishes through a technique called spotting. The photographic images provided in this lesson illustrate how the qualities and elements that go into creating perfect photographs are applied within each of the photographic frames.

● Qualities of the Perfect Photograph

The perfect photograph starts with an excellent image; that is, an image that contains the essential elements and satisfies the criteria that photo editors look for in marketable photographs. You've learned about these elements in lesson 2, "Patterns, Balance, and Order," and lesson 3, "Colors, Tones, and Exposure." In addition to editing photographs for certain visual elements, there are specific qualities that are characteristic to truly outstanding images. In this lesson, you will learn what those qualities are.

The most important quality in any photograph is the subject or the theme. Is the subject or theme readily apparent to the viewer and does the photograph present a universal theme? This is an important concept in the creation of outstanding photography—a mother, for example, as opposed to motherhood. In the former, we have an image of a woman who is someone's mother; in the latter, we have an image that projects the concept of motherhood—the woman in the photograph isn't just someone's mother, she could be *anyone's* mother. The difference is subtle, but the message is perfectly clear to

1. What is the most important quality in any photograph?

Answer
1. The subject or the theme.

75

2. After the selection of an excellent subject or theme, what is the second most important quality in any photograph?

Answer

2. Emphasis of that subject or the theme.

everyone everywhere. This is an example of a universal theme as opposed to a particular subject.

The second most important quality in any photograph is the emphasis of the subject or the theme. Have you focused attention to it? The subject or the theme should clearly stand out in the photograph. In lesson 2, "Patterns, Balance, and Order," you learned how attention is directed to a subject through various techniques like placement, relative size, framing, converging lines, selective focusing, repetition, motion, visual layering, and geometric forms. In this lesson, you will learn how to correctly crop an image for better subject emphasis.

In photograph 4-1, the snake is obscured by its surroundings. Its green color blends in with the vegetation. In addition, the snake—the main subject—is only a small part of the photograph and is not a very significant element in the image. If the entire negative is printed as the photo was taken, the snake will be lost among all the other visual clutter within the photographic frame. However, if you crop the image so that the entire negative shows most of the snake, as in photograph 4-2, then the snake will dominate most of the print area.

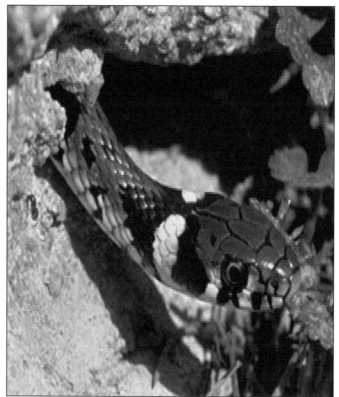

Photograph 4-1—Snake amid foliage (above)

Photograph 4-2 —Cropped image of the snake (right)

In the original negative, the snake was very difficult to see among all the other elements in the photograph; in the cropped negative, however, the snake has been strongly emphasized by making it larger within the photographic frame. All the other visual clutter in the negative has been eliminated in the print. In the newly cropped image, there's no question about the subject of the photograph. Notice, too, how the snake seems to be "observing" the viewer in the cropped image.

The third most important quality in any photograph is simplification of the subject or the theme. You had simplified the image of the tiger (page 23) by cropping out extraneous visual clutter. Simplification means the elimination of all elements within a photographic frame that are not essential to the subject or theme. Simplification can also be achieved through emphasis of the subject—and de-emphasis of background elements—where cropping is not possible. For example, a photographer shoots a basketball player leaping up toward a basketball hoop. The background is filled with spectators sitting and standing in bleachers. By zooming in on the player and filling the frame with as much of the player as possible, the photographer has eliminated much of the background and the cheering crowd, and has successfully emphasized the subject. The photographer can further simplify the image by focusing sharply on the basketball player and throwing the background out of focus.

There are technically perfect images and there are aesthetically pleasing images. Technically perfect and aesthetically pleasing images are winners—always! They represent the truly outstanding images that appeal to the greatest number of people everywhere.

A technically perfect image is one that is focused sharply (unless intended otherwise), properly exposed, and free of physical defects. An aesthetically pleasing image is one that clearly identifies a particular subject or theme, focuses attention to the subject or theme, and simplifies the subject or theme. Technically perfect and aesthetically pleasing images that incorporate universal themes are the kinds of photographs that consistently get published. Universal themes will be discussed later in this lesson.

In addition to a technically perfect and aesthetically pleasing image, there are several other characteristics you should look for in black and white and color prints. These characteristics are summarized in the following subsections.

Characteristics of Good Black and White Prints. You learned in lesson 3, "Colors, Tones, and Exposure," that a good black and white print contains a wide tonal range from the blackest black to the whitest white with many gray tones in between, including light gray, middle gray, and dark gray.

3. After the subject or the theme is chosen, and emphasis is placed on the subject or theme, what is the third most important quality in any photograph?

Answer
3. Simplification of the subject or the theme.

4. A technically perfect image is one that is _____ sharply, properly _____, and free of _____ _____.
5. An aesthetically pleasing image is one that clearly identifies a particular _____ or _____, focuses _____ to the subject or theme, and _____ the subject or theme.

Answers
4. focused, exposed, physical defects
5. subject, theme, attention, simplifies

ZONE 10
Pure White

ZONE 9
Almost Pure White

ZONE 8
Whitish Gray

ZONE 7
Light Gray

ZONE 6
Light Middle Gray

ZONE 5
Middle Gray

ZONE 4
Darkish Gray

ZONE 3
Blackish Gray

ZONE 2
Grayish Black

ZONE 1
Nearly Pure Black

ZONE 0
Pure Black

A print that only contains a lot of black and dark gray tones will lose detail in shadow areas, and a print that only contains a lot of white and light gray tones will lose detail in highlighted areas. It is a good gradation of gray tones that provide detail in a print.

Another characteristic of a good black and white print is contrast. Contrast refers to the distinguishable differences—or lack of differences—between the lightest tones and the darkest tones of gray. In a high-contrast print, you can clearly see the difference between a light gray and a middle gray, or a middle gray and a dark gray. But the difference between a light gray (a Zone 7 gray) and a light middle gray (a Zone 6 gray) is not clearly distinguishable; likewise, the difference between a blackish-gray (a Zone 3 gray) and a grayish-black (a Zone 2 gray) is not clearly distinguishable. In a high-contrast black and white print, the difference between any two closely-related gray tones is readily and easily identifiable. In a low-contrast print, the difference between any two closely-related gray tones is not readily and easily identifiable, and there may be two or three shades of gray tones between a light gray and a middle gray.

Compare the Zone System gray scale to photograph 4-3. Notice that photograph 4-3 contains only a few of the gray tones found on the scale. This is an example of a high-contrast print. The differences between the gray tones are readily and easily distinguishable. Now compare the Zone System gray scale to photograph 4-4. Notice that photograph 4-4 contains most of the gray tones found on the scale. This is an example of a low-contrast print. The differences between the gray tones are not so readily and easily distinguishable.

6. **True or False.** A good black and white print contains pure black, pure white, and many gray tones in between.
7. **True or False.** A print that only contains a lot of black and dark gray tones will lose detail in highlighted areas.
8. **True or False.** A print that only contains a lot of white and light gray tones will lose detail in shadow areas.
9. **True or False.** Contrast refers to the distinguishable differences—or lack of differences—between the lightest tones and darkest tones of gray in black and white photographs.

Answers

6. True

7. False. The print will lose details in the shadow areas.

8. False. The print will lose details in the highlighted areas.

9. True

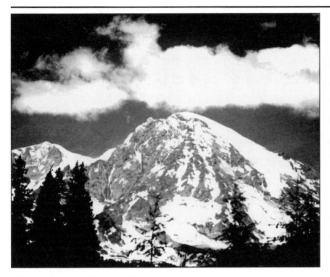
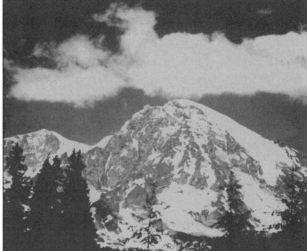

Photograph 4-3—High contrast photograph *Photograph 4-4—Low contrast photograph*

Characteristics of Good Color Prints. Recall that there are four color characteristics that you should concern yourself with when editing photographs: color saturation, color balance, color fidelity, and color contrast.

Saturation. The colors in a photograph should be intense. A bright red fire truck shouldn't appear as flat red; the chrome hubcap of a sports car shouldn't appear as dull gray; a black cat shouldn't appear as charcoal gray, etc.

Balance. A photograph shouldn't contain an overall color cast, unless a color cast was intentionally created for dramatic effect. The green color cast caused by fluorescent lighting is an undesirable element in an image of office workers. A red color cast caused by the setting sun in a photo taken of a sunset is not only desirable, but can dramatically enhance the image. The blue color cast caused by light being reflected off of snow can be desirable or undesirable, depending upon the purpose of the photograph. If the photographer wanted to convey the idea of a cold, wintry day, a blue color cast would be desirable; if, however, the photographer intended to show all the detail in a snowdrift, a blue color cast might obscure some of the detail and, thus, become an undesirable element.

Fidelity. The colors in a photograph should be accurately reproduced as they appeared in the original scene. Although a photo editor has no way to determine what the exact color scheme was really like in the original scene, just from experience in the real world he or she would know that wheat is golden, stormy skies are dark and gray, roses are red, and caucasian skin tones are not really pink. In real life, all the grass in a meadow is not all the same shade of green. Some areas of the grass will be light green, some areas will be dark green,

10. **True or False.**
 Saturation refers to intense color reproduction.
11. **True or False.**
 Balance refers to the principle of thirds.
12. **True or False.**
 Fidelity refers to accurate color reproduction.

Answers

10. True
11. False. Balance refers to color cast.
12. True

and other areas will contain different shades of green between the light greens and dark greens. Fidelity is found in the photograph that faithfully reproduces all these different shades of green. The same photograph would look too artificial if all the grass was reproduced as a single shade of green.

Contrast. Different shades of the same colors should be easily discernible in a good color photograph. Color contrast refers to the distinguishable differences between the lightest and darkest shades of the same color. In black and white photographs, high-contrast and low-contrast images can be very effective. In color photographs, high-contrast images are generally better than low contrast images. The reason for this is that in high-contrast color images there is more separation of the shades of the same colors, and this makes the image more visually stimulating. (Recall the example of a bright red apple sitting on a dark red tablecloth.) If the apple and the tablecloth were nearly the same shade of red (a low-contrast image), the separation of the two elements wouldn't be readily and easily discernible, and the image would appear less stimulating.

> **13. True or False.**
> Contrast refers to the distinguishable differences between tones and shades of the same color.
>
> *Answer*
> 13. True

● Section Self-Test #1

Use a separate sheet of paper to write down your responses to the following questions. Check your responses against the answers provided in appendix A.

1. The most important quality in any photograph is the:
 a. Emphasis of the subject or theme
 b. Subject or theme
 c. Simplification of the subject or theme
2. The second most important quality in a photograph is:
 a. Emphasis of the subject or theme
 b. Subject or theme
 c. Simplification of the subject or theme
3. The third most important quality in a photograph is:
 a. Emphasis of the subject or theme
 b. Subject or theme
 c. Simplification of the subject or theme
4. A technically perfect image is _____ _____, _____ _____, and free of physical defects.
 a. focused sharply, properly exposed
 b. focused sharply, universally recognized
 c. properly exposed, easily identifiable
5. *True or False.* An aesthetically pleasing image clearly identifies a particular subject or theme, focuses attention to the subject or theme, and simplifies the subject or theme.

6. *True or False.* A black and white print that contains only a lot of black and dark gray tones will lose detail in the highlighted areas.

7. *True or False.* A black and white print that only contains a lot of white and light gray tones will lose detail in shadow areas.

8. *True or False.* In a high-contrast black and white print, you can clearly see the difference between gray tones.

9. *True or False.* In a low-contrast black and white print, the difference between any two closely related gray tones is not readily and easily identifiable.

10. *True or False.* Outstanding images are technically perfect, aesthetically pleasing, and incorporate universal themes.

● Universal Themes

Every photograph should contain a story. A good photograph communicates a message to the viewer. The best images contain universal themes, meaningful to people everywhere. Youth, innocence, joy, war, sadness, poverty, love—these are just a few examples of universal themes, which are hallmarks of exceptional photographs! Universal themes grab the viewer's attention, not just because of the image, but because of the emotional tug that universal themes generate in the person viewing the photograph.

Imagine the image of a little barefoot smudge-faced girl in a dirty and tattered dress sitting in the doorway of a run-down building. The scene is an inner-city image. Bits and pieces of litter can be seen directly behind her on the steps of a stairway, and graffiti is scribbled on the walls of the hallway. The image depicts a theme of poverty. Is it a universal theme? You bet it is! Another example of a universal theme is an image of a grief-stricken mother at her only son's graveside. Images like these evoke strong emotions, and people all over the world, from different backgrounds and cultures, relate to them.

Every time you look at a photograph, ask yourself the following questions:

- What is the theme of this photograph?
- Does the theme evoke an emotional tug?
- Is the theme a universal theme, recognized by people everywhere?

Most photographers will shoot a particular subject and totally overlook a theme. For example, there are many professional portrait photographers who have taken hundreds of photographs of children, but have never captured the universal theme of youth or innocence.

> 14. The best images contain _____ _____, meaningful to people everywhere.
>
> *Answer*
> 14. universal themes

A photograph of a lioness and her cub is just a photograph of a lioness and her cub. But capture an image of the cub cuddled close to its mother's body, and the mother affectionately licking the cub's ear, and a universal theme is recognized by all who view the image—a mother's love for her offspring.

Universal themes are not difficult to capture on film, yet most photographers concentrate strictly on the subject itself, and fail to consider a theme.

In lesson 2, the difference between a subject and a theme is defined. Now would be a good time to review that difference.

Subject. With respect to photography, a thing that can be physically dealt with, such as a flower, an animal, or a person, and graphically fixed in its actual form.

Theme. With respect to photography, an idea or concept that cannot be physically dealt with, and must be expressed in an abstract way; for example, war or peace, happiness or sorrow, love or hate.

Although they are closely related, there is a significant difference between a subject and a theme. One is in the physical form and the other is in the abstract form. Reproducing a physical subject on film is one thing; communicating an abstract theme, especially a universal theme, on film is quite another. The elements of a photographic theme may include physical subjects, but the photographing of one or more subjects may not include a theme.

Not All Themes Are Universal Themes. People everywhere recognize universal themes. If a photograph is being published in North America only, a theme that would be recognized by North Americans and not, let's say, Asians or Africans, is okay. However, if the same photograph is being published in an international publication, Asians and Africans, and people from other cultures around the world might not recognize its theme. In other words, a theme that is culture-based may not be a universal theme. For example, a photograph that depicts a slice of life in 1950s America—a culture-based, nostalgic theme—would only be significant to Americans. Such a theme would be absolutely meaningless to people in Bangladesh.

Examples of Universal Themes. *The Beginning of Life.* Imagine a photograph in which a man is joyously lifting a newborn baby into the air. The viewer only sees the baby gently clutched in the palms of the man's hands. How does the viewer know they are a man's hands? Because of their size and structure. The viewer doesn't actually see the man, only his arms and hands. The newborn occupies most of the photographic frame. Blood and other bodily fluids are still on the baby's body, and the severed and knotted umbilical cord can be easily seen. Everyone will recognize this universal theme of the beginning of life. This image of new life is a powerful universal theme.

15. A subject is a _____ that can be physically dealt with, and graphically fixed in its actual form; a theme is a _____ or _____ that cannot be physically dealt with, and must be expressed in an _____ way.

Answer
15. thing, idea, concept, abstract

16. **True or False.**
People everywhere recognize universal themes.

Answer
16. True

82

The Ending of Life. Universal themes are usually found in opposite pairs. Where there is the beginning of life, so there is the ending of life. Imagine a photograph in which a father is kneeling at an isolated grave site. The viewer sees only a man and a simple gravestone within the photographic frame. The man is weeping, and the gravestone is marked Jimmy Johnson, My Beloved Son, November 22, 1988–August 18, 1995. The viewer realizes from the dates engraved on the stone that this man's son died before reaching the tender age of seven. The universal theme communicated to everyone everywhere from this image is unmistakable: the grief and anguish caused by the sudden and unexpected loss of a loved one.

A Mother's Love for Her Young. Not all images that communicate universal themes include people. The photograph of the lioness and her cub effectively demonstrates the love of a mother toward her offspring. It makes no difference whether the mother is a human being or an animal. Recall the image in which the cub is cuddled closely to its mother, and its mother is affectionately licking its ear. There is an expression of complete satisfaction and contentment on the cub's face. Everyone everywhere would recognize the theme in this image.

The Desire to Survive. Self-preservation and survival are strong universal themes. Such a theme can be successfully communicated through inanimate objects. In lesson 2, "Patterns, Balance, and Order," you were given an example of how roses effectively demonstrated their desire for the life-sustaining rays of the sun—their desire to survive. In this photograph, there are no humans or animals within the frame. The viewer sees only roses against a dark background. But the roses are stretching upward toward the sky as if they are delighted to receive the warm rays of sunlight that provide them with a source of energy and the ability to grow and flourish, without which they would soon wither and die.

> **Self-preservation and survival are strong universal themes.**

17. The beginning of life, the ending of life, a mother's love for her young, and the desire to survive are all examples of _____ _____.

18. Universal themes are _____ or _____ that cannot be physically dealt with, and must be expressed in an _____ way.

19. In the photograph of the newborn baby, the universal theme is the beginning of life. What three elements in this photograph are used to express the universal theme?

Answers

17. universal themes

18. ideas, concepts, abstract

19. The universal theme of the beginning of life is expressed by the hands of the man lifting the newborn baby into the air, the blood and bodily fluids that are still on the baby's body, and the knotted umbilical cord.

● Section Self-Test #2

Use a separate sheet of paper to write down your responses to the following questions. Check your responses against the answers provided in appendix A.

1. Which of the following represent universal themes?
 a. Flowers, animals, and other natural things
 b. Youth, innocence, love, and other abstract concepts
 c. Easily identifiable subjects

2. A universal theme is found in which image?
 a. A soldier sitting at a dinner table next to his sweetheart, his arm resting on the chair behind his sweetheart's back
 b. A soldier standing next to his sweetheart in an airport, the soldier waiting for his plane to depart
 c. A soldier greeting his sweetheart with a tight embrace, a passionate kiss, and his hat falling from his head

3. Why do you feel the image you selected in question 2 is a universal theme? Explain your answer.

4. *True or False.* A theme is a *thing* that can be physically dealt with and graphically fixed in its actual form.

5. Recall the image of the little barefoot smudge-faced girl in a dirty and tattered dress sitting in the doorway of a run-down building. If this image were cropped to show only a close-up of the little girl's face, would it still represent a universal theme?
 a. Yes! The expression on the little girl's face is enough to express a universal theme. We know by looking at the image that the little girl is unhappy about something.
 b. No! Without the other elements in the photograph—the dirty and tattered dress, the litter on the steps of the stairway, and the graffiti scribbled on the walls of the hallway—there would be no hint of the little girl's environment. The photograph would be nothing more than a portrait of a child.

6. A young man is standing next to his classic 1957 Thunderbird. He has a broad smile on his face and he is passionately stroking the roof of the car. Is this an example of a universal theme?
 a. Yes! Everyone who looked at the photograph would know that the car was an old but restored vehicle. The year or make of the car is not important. The apparent age of the car and the broad smile on the young man's face conveys a universal message.

> The photograph would be nothing more than a portrait of a child.

b. No! People everywhere recognize a universal theme. The significance of the restored 1957 Thunderbird and the smiling young man may be easily identified in America, where classic automobiles are admired. In cultures where automobiles are rarely seen, a viewer might not understand why the young man is so attached to the car.

● What to Look for in Negatives and Transparencies

Negatives and transparencies will require more of your attention than prints. Why? Because a print that has already been processed from a negative or transparency can be easily examined for prepublication details. The proof is already in your hands. When working with negatives and transparencies, you'll want to be reasonably sure that the developed print will be technically flawless before having a print made. Always examine negatives and transparencies for the following characteristics before having finished prints developed from them:

- As with prints, examine negatives and transparencies for technically perfect and aesthetically pleasing images. Here is where a photo editor's magnification loupe will be of great help to you. Use the loupe with negatives and transparencies when examining images for sharpness and physical defects like scratches and other imperfections. (A good way to examine transparencies is by projecting the image through a projector onto a screen or white wall; use a light table when examining negatives and when examining transparencies without a projector.)
- Examine each negative and transparency for cleanliness. There should be no scratches, blemishes, stains, dust particles, fingerprints, or other imperfections that might impair the image from which the finished print is made. (Dust particles and fingerprints can be easily cleaned from the negative or transparency by the darkroom technician or the developing laboratory. Scratches, blemishes, or other imperfections may not be correctable. Consult with a lab technician before using such images.)
- Examine each negative and transparency for light qualities (as opposed to proper exposure). A properly exposed image can have poor light qualities. For example, the large display window of an elegant store may be properly exposed, but the reflected light on the window prevents the viewer from seeing what's behind the window (a polarizing filter would have solved this problem). Another

Examine each negative and transparency for cleanliness.

. . .recall that red is really cyan, blue is yellow, and green is magenta.

example, and one we are all familiar with, is the background light being reflected off an object from a strobe light or flash gun. In these instances, the reflected light usually interferes with some part of the image or, sometimes, the entire image.

• Examine each negative and transparency for color saturation, color balance, color fidelity, and color contrast. When examining a color negative, however, recall that red is really cyan, blue is yellow, and green is magenta. Therefore, a negative can be examined in much the same way a transparency is examined, except for the colors. (In a transparency, reds are reds, yellows are yellows, and blues are blues.) In the case of negatives, if all the other characteristics are within acceptable limits—technically perfect, technically pleasing, no imperfections, proper lighting qualities, and the negative is clean—have the negative developed into a finished print and then examine the print for the four basic color characteristics.

20. **True or False.** The photo editor's magnification loupe is used to examine negatives for image sharpness and physical defects.
21. **True or False.** Fingerprints on negatives are okay, but negatives must be free of scratches, blemishes, stains, and dust particles.
22. **True or False.** A properly exposed negative will not exhibit poor light qualities.
23. **True or False.** Color negatives should be examined for color saturation, color balance, color fidelity, and color contrast.

Answers

20. True

21. False. Fingerprints that are not cleaned from negatives will show up in the finished print.

22. False. A properly exposed negative can still exhibit poor light qualities from reflected natural light, strobe light, or flash guns.

23. True

I've already mentioned dust particles, but this issue is so important in dealing with negatives and transparencies that it deserves further discussion. Tiny spots on the finished print are usually the result of dust particles that were not cleaned from the negative or transparency. Dust particles that translate into tiny light or dark spots can be annoying—at best!—to the viewer, and can distract the viewer's attention from the main subject or theme of the photograph. There is no excuse for printing an image with tiny spots all over the photograph simply because the darkroom technician or the commercial developer was too lazy to clean the negative or transparency before

developing a print from it. Never present such images to a photo editor for publication consideration. Sometimes the dust particles work their way onto the printing paper. This is unavoidable. Dust particles are nearly impossible to see on white printing paper. In this case, a few tiny spots on the finished print can be removed through a process called spotting, which you will learn about later in this lesson.

24. **True or False.** Tiny light or dark spots on the finished print are usually the result of dust particles that were not cleaned from the negative.

Answer
24. True

● Printing from Negatives or Transparencies

You should have a basic understanding of how negatives and transparencies are developed into prints. We're not going to go into the technical developing and printing processes here, because you're not required to know them. Most publication houses have their own laboratories and darkroom technicians. Where a publishing house does not have its own laboratory, the photo editor has two options by which to have prints developed from negatives or transparencies: local commercial laboratories or custom processors. The difference between the two is explained later in this lesson.

Developing a print from a negative, whether the negative is black and white or color, is a very simple procedure. The darkroom technician places the negative in an enlarger and projects its image onto a sheet of enlarging paper. The exposed paper is then put through a developing and printing process, and the finished print ends up in your hands. If the finished print is a color print, you will hear it referred to as a C-print; if the finished print is a black and white print, you will usually hear it referred to as a silver print, because the image is formed from black metallic silver.

The darkroom technician places the negative in an enlarger. . .

25. A color print is also referred to as a _____ -print.
26. A black and white print is also referred to as a _____ print.

Answers
25. C
26. silver

Developing a print from a transparency is a little more complicated. There are two ways by which a print can be developed from a transparency: internegative process and Cibachrome process.

Internegative Process. The darkroom technician projects the image of the transparency onto a sheet of color negative material. From this sheet of color negative material, the technician ends up with a color negative. Because this negative was developed from the original transparency and must still be used for developing a finished print, the negative is referred to as an internegative. Once the technician has developed the internegative, he or she then places it in an enlarger and makes a color print from it exactly as from any other color negative. Through the internegative process, you end up with your original transparency plus a color negative.

Cibachrome Process. In this process, the darkroom technician makes a print directly from the transparency without developing a color negative. The transparency is placed in an enlarger and its image is projected onto Cibachrome printing paper exactly as though it were a negative; the result is a Cibachrome print.

The Internegative Process vs. the Cibachrome Process. When developing prints from a transparency, what are the differences between the internegative process and the Cibachrome process? There are several differences that you should be aware of.

The Cibachrome print has a very high-gloss surface, whereas prints that are developed from internegatives are available in a variety of finishes, such as matte, semi-matte, silk, tapestry, glossy, semi-glossy, and even a canvas-like finish. From a publishing standpoint, most of the prints you will work with will have a high-gloss or semi-glossy finish. Therefore, it doesn't much matter whether the darkroom technician uses the Cibachrome process or the internegative process when developing your prints.

Some photographers and developers will insist that developing prints through the Cibachrome process is more expensive than through the internegative process. This is true only when a large number of the same image is being developed and printed. The internegative process is less expensive for multiple copies of the same image. However, the photo editor would be interested only in developing a single print for publication purposes and, from a cost perspective, there would be no significant difference in one process over the other.

Cibachrome prints tend to be more contrasty. In other words, Cibachrome prints will not show the difference between any two closely-related shades of the same color as easily as a print that was developed through the internegative process. But because of their high-contrast characteristics, Cibachrome prints may give a flat image

27. Because a negative is developed from a transparency, and is used for developing a finished print, the negative is referred to as an

_____.

28. Through the internegative process, you end up with your _____ transparency plus a

_____ _____.

29. **True or False.**
The Cibachrome process does not require an internegative.

Answers
27. internegative
28. original, color negative
29. True

The internegative process is less expensive for multiple copies.

(a low-contrast image) some added zest. If you have a high-contrast image, instruct the darkroom technician to use either the Cibachrome or internegative process for developing prints. If you have a low-contrast image, and wish to add more punch to the image (that is, be able to discern a greater distinction between any two shades of the same color), request the Cibachrome process. If you have a low-contrast image and wish to maintain those characteristics in the finished print, use the internegative process.

The greatest difference between the Cibachrome process and the internegative process rests in their developing and printing latitudes. Generally, in a transparency, what you see is what you get. There is little or no room for enhancement of the image. Therefore, the Cibachrome process translates the image of the transparency to the finished print exactly as it appears in the transparency. On the other hand, an internegative can be enhanced. Color characteristics, exposure, contrast, etc., can be manipulated, within certain limits, and the finished print can actually be improved. If the image of a transparency is perfectly acceptable for publication purposes, use either the Cibachrome or internegative process for developing a print; if you wish to make slight changes in color characteristics, exposure, contrast, etc., use the internegative process. Once the internegative has been developed, the darkroom technician can work with it to effectively enhance the image.

> **There is little or no room for enhancement of the image.**

30. **True or False.** Cibachrome prints are glossy, have more contrast than prints made from negatives, and cost more to develop.

31. **True or False.** When developing prints from transparencies using the Cibachrome process, what you see in the transparency is what you get in the finished print.

Answers

30. False. Individually, Cibachrome prints cost no more than prints made from negatives.

31. True. Prints developed directly from transparencies have very little latitude for enhancement.

● Commercial Laboratories vs. Custom Processors

You have two options for developing and printing photographs: commercial laboratories or custom processors. There is a world of difference between the two. As a photographer who wishes to publish his or her photographic images, you should become thoroughly familiar with the services offered by each.

Commercial Laboratories. Commercial laboratories are the least expensive, but they usually offer far fewer services than custom processors. Film is processed through a machine for standard assembly line production of your prints. Commercial laboratories do not, and cannot, give your film individual attention. Because of this, they may not be able to meet your printing requirements. For example, most commercial laboratories will only print common enlargement sizes: $3\frac{1}{2}$" x $5\frac{1}{2}$", 4" x 6", 5" x 7", and 8" x 10". If you required a cropped image size of, let's say, $6\frac{1}{2}$" x 9", most commercial labs would not be able to accommodate you.

Warning: Realize that not all commercial laboratories are equally good. Kodak is an excellent processor and the people who oversee Kodak's quality control and public relations are very proud of Kodak's highly-regarded reputation. This is, however, not true of all drugstore or one-hour processors. Some are excellent, some are good, some are mediocre, some are poor. . .and some should not be in the business of processing film. Be cautious in your selection of a commercial laboratory to handle your entire photo developing and printing needs.

I would also like to offer a word to the wise at this time. Although a commercial processor may advertise "We Use Kodak Paper," this in no way ensures that they process your prints at a Kodak laboratory. The fact is, they don't! If you want your processing done by Kodak, you must specifically request this service. We recommend that, because Kodak is an excellent film processor that utilizes high-quality control standards, you use Kodak processing as a standard by which to judge other commercial processors. If another processor matches Kodak's quality at a lower price, by all means consider the services of the other processor.

Other limitations of commercial processors are:

- Limited choice of finishes and paper weights
- Limited choice of specific cropping sizes
- Unusual cropping sizes not available
- Spotting services are not available (this topic is covered later in this lesson).

For standard developing and printing services, a good commercial laboratory will meet your requirements at low cost. To get an idea of what types of services are available, get brochures and technical specification sheets from all the commercial laboratories in your area, and keep this information on file.

Custom Processors. While commercial processors use automated machines and standard processing procedures, custom processors

I would also like to offer a word to the wise at this time.

32. **True or False.**
Commercial labs are the least expensive, and they usually offer more services than the custom processors.

33. **True or False.**
Commercial processors who advertise "We Use Kodak Paper" process your prints at a Kodak laboratory.

Answers

32. False. Commercial labs are usually less expensive, but they offer fewer services than custom laboratories.

33. False

will take your negative or transparency and have it individually printed by a technician. The technician will not only print the photograph to your specifications and requirements, but may spend up to an hour or more to ensure that the print is the best print possible that can be made from the negative or transparency provided.

Custom processing costs more than commercial processing, with the extra cost doubling and sometimes tripling over that of commercial processing costs. Therefore, always know, in advance, what the costs will be for the services you require.

Warning: Some unscrupulous commercial processors may refer to their developing and printing services as custom prints. Watch out for catch phrases like "Custom Quality Prints" or "Custom Prints at Commercial Prices." Commercial processors cannot give you custom prints at commercial prices without losing money.

Custom processors can offer you the following services:

- Unlimited choice of finishes and paper weights
- Unlimited choice of cropping sizes (a custom processor will crop a photograph to almost any size, even to totally unconventional dimensions)
- Burning, dodging, and spotting services are available
- Individual control of color saturation, balance, fidelity, and contrast of color photographs
- Individual manipulation of the Zone System during the developing and printing process for better tonality in black and white photographs

These are only a few of the services available from a custom processor. For other services available, get brochures and technical specification sheets from all the custom processors in your area and keep this information on file. As a photographer who wishes to market your images, you should have access to the services of at least one custom processing lab that will be able to meet all your photo processing and printing requirements.

> **Custom processing costs more than commercial processing.**

34. **True or False.** Custom processors will take your negative or transparency and have it individually printed by a technician.
35. **True or False.** The phrases "Custom Quality Prints" and "Custom Prints at Commercial Prices" ensure that you are receiving custom processing services.

Answers

34. True
35. False. Beware of such advertising phrases.

● **Section Self-Test #3**

Use a separate sheet of paper to write down your responses to the following questions. Check your responses against the answers provided in appendix A.

1. *True or False.* A photo editor's magnification loupe is the best way to examine negatives and transparencies for sharpness and physical defects.

2. Tiny spots on a finished print are usually the result of:
 a. Water droplets
 b. Dust particles
 c. Improper developing of the film

3. *True or False.* In the internegative process, the darkroom technician projects the image of the transparency onto a sheet of color-negative material.

4. Cibachrome prints tend to be:
 a. Flat
 b. Contrasty
 c. Deeply color saturated

5. You have a transparency with a low contrast image and wish to add some zest to the finished print. You would instruct the darkroom technician to:
 a. Develop a print using the Cibachrome process.
 b. Develop a print using the internegative process.
 c. Develop a print by manipulating the colors.

6. You have a transparency with a great image, but you would like to improve its color characteristics. You would instruct the darkroom technician to:
 a. Make a print directly from the transparency
 b. First, make a negative from the transparency, then make a print from the negative
 c. Use a color-compensating filter when making a print from the transparency

7. You have a color negative and would like to get several 5" x 7" prints made from it for publication purposes. No other enhancements to the image are required. You would:
 a. Send the negative to a commercial laboratory
 b. Send the negative to a custom processor

8. The negative referred to in question 7 has some minor marks on it. You would use the image for publication purposes if the marks could be removed. You would:
 a. Send the negative to a commercial laboratory
 b. Send the negative to a custom processor

You have a
transparency
with a great
image. . .

9. *True or False.* A good commercial laboratory can offer unlimited choices of finishes and paper weights; unlimited choice of cropping sizes; burning, dodging and spotting services; individual control of color saturation, balance, fidelity, and contrast of color photographs, and individual manipulation of the Zone System in black and white images.

10. *True or False.* A custom processor is more expensive than a commercial laboratory, but a custom processor is able to meet all your photo processing and printing requirements.

● Cropping

In photograph 4-5a, the subject is the woman posing next to the fence. Let's suppose all you want of this image is a head-and-shoulders portrait of the subject. In the format shown, the subject occupies less than half the entire frame of the photograph; most of the photograph contains nonessential and distracting elements that direct the viewer's attention away from the subject. Notice that the photograph is in the landscape (horizontal) format. How can this photograph be effectively cropped to include only the head and shoulders of the subject, while maintaining visual impact?

The subject occupies less than half the entire frame. . .

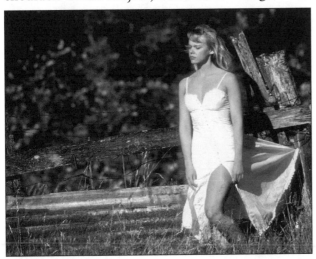

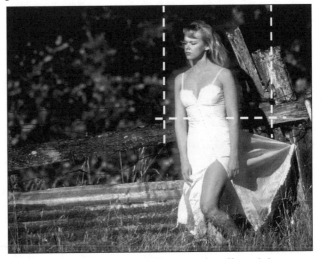

Photograph 4-5a—Portrait of a woman posing next to a fence

Photograph 4-5b—Crop lines at the elbow joints

Cropping the Print. First, let's draw crop lines around the subject's head and shoulders to indicate the part of the image we wish to enlarge (see photograph 4-5b). This will be our initial crop. Notice that the bottom crop line cuts across the subject's arms. A good rule to follow when cropping images of people is never to crop along an elbow joint. When an arm has been cropped along an elbow joint, the viewer perceives the limb as being amputated. In our initial crop, we have "amputated" the arms of the lovely subject. Always crop arms midway between the shoulder and the elbow or between the

elbow and the wrist. Of the two choices, it's almost always better to crop the arm between the shoulder and the elbow. Let's adjust the bottom crop line in our initial crop by raising the line to about midway between the subject's shoulders and elbows (see photograph 4-5c). Apply the same logic when cropping across the legs of a subject. A leg that has been cropped along the knee joint looks amputated. Always crop legs midway between the thigh and the knee or between the knee and the ankle. Of the two choices, it's almost always better to crop the leg between the thigh and the knee.

Photograph 4-5c is a better crop, but subject placement can be improved. Notice that in photograph 4-5c, the subject is facing toward the left of the frame (viewer's perspective). Compositionally, this feels awkward to most viewers. The subject is looking out of the photographic frame. This compositional flaw can be easily corrected by moving the left crop line farther away from the subject, as shown in photograph 4-5d.

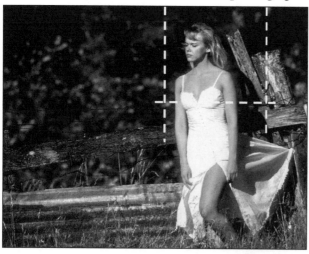

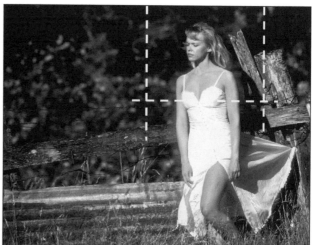

Photograph 4-5c—
Crop lines between shoulders and elbows (above left)

Photograph 4-5d—
Adjusting the left crop line (above right)

Photograph 4-6—
Cropped image of woman (right)

By adjusting the left crop line, we open up the frame to the left of the subject. Viewer discomfort due to the subject looking out of the frame has been all but eliminated. However, by moving the left crop line farther away from the subject, we have effectively centered the subject within the photographic frame. Let's see if we can further improve this image by applying the principle of thirds.

One of the compositional principles you learned about in lesson 2, "Patterns, Balance, and Order," is that if the subject is looking toward the left or right in the photographic frame, he or she should be positioned facing inward toward the center of the frame. That is, if the subject is looking toward the left of the frame, place the subject at or near the right dividing line; if the subject is looking toward the right of the frame, place the subject at or near the left dividing line. In photograph 4-5d, the subject is looking toward the left. Let's see if we can place the subject at or near the right dividing line.

By moving the right crop line inward until it is aligned along the subject's left arm (right side from the viewer's perspective), we have effectively placed the subject toward the right side of the frame (the subject is no longer centered). Notice that the subject is now positioned along the right vertical one-third grid line of the frame and looking inward toward the center of the frame (see photograph 4-6).

Photograph 4-6 represents the image of the woman after the darkroom technician enlarged the photograph according to our cropped specifications. The image has been enhanced in the following ways: The subject of the photograph has been greatly emphasized; the photograph has been simplified; the photograph has been given added impact value.

The subject has been greatly emphasized because she now occupies most of the photographic frame (she is much larger in the cropped photograph than in the original photograph). The photograph has been simplified because all the empty space around the woman has been eliminated and is no longer distracting to the viewer. The photograph has been given added impact through subject placement and application of the principle of thirds. Finally, the photograph is now in the portrait (vertical) format—a more pleasing format for a close-up portrait.

That's all there is to cropping a photograph. It's up to you to determine whether cropping can enhance an image. If there are other elements in a photograph with a particular subject, and the elements complement or enhance the subject, then leave those elements in the photographic frame. If the elements might distract the viewer then, by all means, crop out the offending clutter. Of course, as demonstrated in photograph 4-6, cropping can be used to simply isolate and enlarge a particular area of an image.

It's up to you to determine whether cropping can enhance an image.

95

36. By _____ a photograph, we can eliminate _____ and _____ elements that may direct the viewer's attention away from the subject.

37. A good rule to follow when cropping images of people is never crop along an _____ _____ or a _____ _____.

38. Another good rule to follow when cropping photographic images is to leave those elements that _____ or _____ the subject in the photograph, and crop out those elements that _____ the viewer's attention away from the subject.

Answers

36. cropping, nonessential, distracting

37. elbow joint, knee joint

38. complement, enhance, distract

38. True or False.

Negatives and transparencies may be cropped inside a glassine or acetate pocket.

Answer

38. True

Cropping the Negative or Transparency. The best and easiest way to crop an image is to have a print made from the negative or transparency and then crop the print. However, it is possible to crop an image directly from the negative or transparency. Simply enclose the negative or transparency in a glassine or acetate pocket and draw your crop marks directly on the pocket. Make sure the negative or transparency can't move around inside the pocket. If the negative or transparency can move around freely inside the pocket, the crop marks on the outside of the pocket will not correspond to those areas on the negative or transparency you wish to have cropped.

Caution: When drawing your crop marks on a glassine or acetate pocket housing a negative or transparency, apply light pressure to the pocket. If you apply too much pressure against the pocket with your marking device, you may damage the negative or transparency by putting pressure marks or scratches on the film base.

● Spotting

Earlier in this lesson I mentioned that dust particles on negatives and transparencies can result in tiny light or dark spots on developed prints. Sometimes, a print will contain minor imperfections and marks due to scratches, fingerprints, water spots, and foreign matter, such as hair that has worked its way onto the negative or transparency. Fortunately, the darkroom technician can often correct such minor imperfections on the developed print using a technique called spotting.

Spotting is a process in which a darkroom technician paints out minor imperfections on the finished print. Using a tiny paintbrush and an appropriate dye, the darkroom technician corrects imperfections on black and white and color prints. Spotting is usually done to save time and money. Developing another print of the same image,

especially if the print was custom processed, might take a day or more depending on the lab's workload, and the cost for duplicating the print would not be justified. Spotting out minor imperfections on a print takes only a few minutes and is inexpensive, too.

Spotting is a very simple technique to learn. You may want to do your own spotting on photographic prints. For now, just be aware that minor imperfections can be corrected on prints by the darkroom technician at your request. Once you've developed a working relationship with a custom processing lab, you can always approach the darkroom technician and ask him or her to teach you the fundamentals of spotting. You can also teach yourself the art of spotting photographs. There are several good how-to publications available on photo spotting techniques. For the few dollars spent on spotting dyes and brushes, you can practice spotting on a few black and white or color prints until you have mastered the art. With a little practice and a little patience, you'll be spotting photographs like a pro!

Note: Different types of color prints require different types of dyes. When purchasing dyes for spotting color prints, make sure your photo dealer provides you with the right dye for the type of color print you want to spot. For example, dyes for C-prints are different from dyes for Cibachrome prints. And, of course, there are special dyes for silver prints.

● Lesson Summary

Before continuing on to lesson 5, "Editing Photographs for Publication," make sure that you have learned all about the qualities that go into creating the perfect photograph. You should now have a thorough understanding of the following concepts, and you should know how to apply these concepts to photographic images for the purpose of selecting and evaluating photographs for publication:

- Characteristics of good black and white prints
- Characteristics of good color prints
- Universal themes
- What qualities to look for in negatives
- What qualities to look for in transparencies
- Internegative process
- Cibachrome process
- Using commercial laboratories
- Using custom processors
- Cropping prints
- Cropping negatives
- Cropping transparencies
- Spotting

39. True or False.
Spotting is a process in which a darkroom technician paints out minor imperfections on the negative.

Answer

39. False. Spotting is a process used to paint out imperfections on the finished print.

40. True or False.
The application of spotting ink on a print requires the knowledge of a skilled darkroom technician.

Answer

40. False. Spotting is a very simple technique to learn.

Editing Photographs for Publication

● Introduction

Lessons 2 through 4 provided the basic foundation for this lesson. In this lesson, you will be guided through all the steps of evaluating and editing a photograph for publication. Most importantly, you will learn to target the audience that will be most receptive to the kind of photographs you wish to market. In the last section of this lesson, you will learn the five most important criteria for selecting and editing marketable photographs for publication purposes, and you will learn how to apply these criteria to your own images. The photographs provided in this lesson illustrate the evaluation and editing process, and how to transform a good image into an outstanding image. We will begin this lesson with a basic photograph in landscape format; we'll evaluate it, edit it, and crop it for visual impact, ending up with a better image in portrait format. Finally, you will learn about the importance of maintaining aspect ratio when reducing or enlarging photographs, and why maintaining aspect ratio is important in the publishing and photo marketing industry.

You will learn about the importance of maintaining aspect ratio. . .

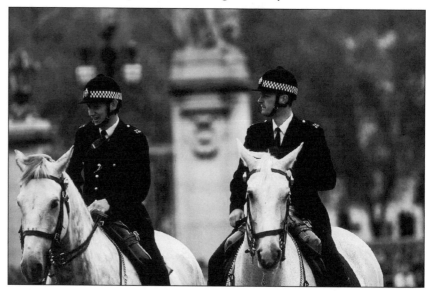

Photograph 5-1—Italian police officers on horseback

● Evaluating a Photograph for Publication

Your first step in editing a photograph is to evaluate its potential for publication, that is, its marketability. Let's suppose you have selected several photographs for possible publication in a travel magazine. One of the photographs (photograph 5-1) is an image of two Italian police officers on horseback in a medium-size city in Italy.

Is this a technically perfect image? This is the first question you must ask yourself before you begin the evaluation process. The three criteria for determining if a photograph is technically perfect are:

- Is the subject in sharp focus?
- Is the image properly exposed?
- Is the photograph free of physical defects?

If the answers to these questions are yes, then you may continue with the evaluation process. If the answers are no, disqualify the photograph for publication consideration and review lesson 4 for a detailed description of technically perfect photographs.

Is this an aesthetically pleasing photograph? This is the second question you must ask yourself before you begin the evaluation process. The three criteria for determining if a photograph is aesthetically pleasing are:

- Is the subject or theme clearly identified?
- Is attention focused on the subject or theme?
- Has the subject or theme been simplified?

Again, if the answers to these questions are yes, then you may continue with the evaluation process. If the answers are no, disqualify the photograph for publication consideration and review lesson 4 for a detailed description of aesthetically pleasing photographs.

One important point that must be stressed is that you cannot reasonably expect to apply all the criteria you learned in this book to every photograph that you evaluate and edit for publication or exhibition. Some photographs might contain many of the criteria discussed in this book, while other photographs might contain only two or three of those criteria. For example, a close-up portrait of a young woman might include subject emphasis through relative size, placement, and selective focusing, with only skin-tone colors prevailing in most of the photograph. A scenic photograph, on the other hand, might incorporate framing, converging lines, visual layering, geometric forms, many different colors and shades of colors, and sharp focus on everything within the photographic frame. Every photograph must be evaluated according to its purpose and its content.

1. A technically perfect photograph is one that is sharply _____, properly _____, and free of _____ _____.

Answer

1. focused, exposed, physical defects

2. An aesthetically pleasing photograph is one in which the subject is _____ _____, attention is _____ on the subject or theme, and the subject or theme has been _____.

Answer

2. clearly identified, focused, simplified

3. True or False.

Although there are certain criteria that all images can be examined for, every photograph must be evaluated according to its purpose and its content.

Answer

3. True

4. True or False.

Some photographs cannot be evaluated for certain exposure characteristics.

Answer

4. True. Color photographs cannot be evaluated for gray tones or other such characteristics of black and white photographs.

For example, the purpose of a portrait is to create a flattering likeness of the subject and to capture the essence of the subject's character, whereas the purpose of a scenic is to capture a feeling of the peace, tranquility, and beauty of the landscape. While each of these images should be evaluated in different ways, as you learned in lessons 2–4, there are certain criteria that *all* images can be examined for.

Having determined that photograph 5-1 is a technically perfect and aesthetically pleasing image, you must now carefully scrutinize the photograph for some of the other criteria that a photo editor looks for. Begin your evaluation by examining the photograph for the following exposure characteristics:

- Overexposure
- Underexposure
- Blurring or fuzziness around objects
- A good range of gray tones in black and white images
- Areas of solid black and pure white in black and white images
- Details in highlights and shadows
- Saturated color
- Correct color balance
- Correct color fidelity
- Sharp focus (unless intended otherwise)

You determine, after evaluating the photograph for the exposure characteristics listed above, that the photograph is not over- or underexposed, there are details in the highlights and shadows, the color is saturated with correct balance and fidelity, and the subjects of the photograph are in sharp focus. The criteria for black and white images do not apply, because the photograph of the Italian police officers was shot in color.

Satisfied with your evaluation of exposure characteristics, you continue your examination of the photograph for the following impact-value characteristics:

- Attention-getting subject
- Emotional impact ("grabbing" power)
- Positive or negative response
- Visual impact (attracts viewers)
- Expression of a universal theme
- Effective use of the principle of thirds

You determine, after evaluating the photograph for the impact-value characteristics listed above, that the photograph contains an

attention-getting subject. You're a little concerned that emotional impact is lacking in this image, but you know that the photograph will be used in a travel magazine. You also know that most people who read travel magazines are more interested in seeing images that illustrate the customs and flavor of a locality than emotional images that may deal with social issues. All else considered, the image projects a positive feeling, has visual impact, and expresses a universal theme—law and order. You determine, however, that although the principle of thirds has been put to use in this image, it could have been applied more effectively. You make a note.

Still satisfied with your evaluation of the photograph, you continue your evaluation for the following identification characteristics:

- Easily identifiable subject
- Easily identifiable theme
- Easily recognized universal theme

The Italian police officers are easily identified as the subjects of the photograph, and the theme is easily identified as law and order. The theme is also easily recognized as a universal theme that will be understood by people everywhere. The key phrases here are "easily identified" and "easily recognized." Although you evaluated the photograph for an identifiable subject and a recognizable theme with respect to impact value, you want to make sure that the subject is "easily identified" and the theme is "easily recognized." These characteristics are the hallmarks of outstanding images.

You continue your evaluation of the photograph for one or more of the following subject-emphasis characteristics:

- Placement
- Relative size
- Framing
- Converging lines
- Selective focusing
- Repetition
- Motion
- Visual layering
- Geometric forms

As you evaluate the photograph for subject-emphasis characteristics, you decide that placement and relative size could be improved upon. Although the subjects in the photograph are easily identified, you determine that visual impact could be significantly improved by filling more of the frame with the images of the police officers. You

5. True or False.

A photograph cannot possess visual impact if it lacks emotional impact.

Answer

5. False. Emotional impact is a powerful element that grabs the viewer's attention, but it need not be present for a photograph to possess visual impact.

6. True or False.

In all outstanding images, the subject and the theme are easily identified, and a universal theme is easily recognized.

Answer

6. True

make a note and continue with the evaluation. Subject emphasis through framing and converging lines are not present in this photograph, but subject emphasis through selective focusing has been effectively used to force the viewer's attention to the police officers. Subject emphasis through repetition, motion, and visual layering are not employed in this photograph, nor are they necessary. The subjects have been effectively emphasized through one or more of the subject-emphasis characteristics. Although there are geometric forms in the photograph, they are not used to emphasize the subjects.

As you approach the end of your evaluation process, you examine the photograph for the following distracting characteristics:

- Unnecessary background clutter
- Unnecessary foreground clutter
- Elements that compete for attention
- Large areas of empty space
- Bright spots or ghosts of light

Finally, you examine the photograph for elements that may distract the viewer's eye from the main subject. You notice areas of the image that can be improved upon. This photograph contains too much background clutter that competes for attention and draws the viewer's eye away from the main subjects. There are bright spots or ghosts of light in the upper right area of the photographic frame and distracting background objects in the lower right area of the frame. The streetlights in the upper left portion of the frame look like they are dangling on each side of the officer's head. Again, you make a note of the distracting characteristics.

Armed with the information gained from your evaluation, you begin asking yourself questions. How can this photograph be improved to enhance its marketability? Although this is a good photograph, how can it be transformed into an outstanding photograph? Does the photograph require two police officers on horseback to convey an image of an Italian police officer? Would two Italian police officers on horseback project any more information about what the Italian police look like than a single police officer on horseback? In this case, the answer is no! The only question is, which officer should you eliminate from the photograph? The answer should be obvious: the officer on the left of the frame. You refer to your evaluation notes and are reminded of some issues that need to be addressed: Is there a way to alter the image for more effective application of the principle of thirds? Can the relative size of the subject be increased, and subject placement be improved? Can the distracting bright spots and ghosts of light be eliminated from the photograph?

7. True or False.

More than one subject-emphasis characteristic must be used to effectively focus the viewer's attention on the main subject.

Answer

7. False. A single subject-emphasis characteristic can effectively focus attention on the subject; however, use of more than one subject-emphasis characteristic reinforces attention to the subject.

8. True or False.

Unnecessary elements in a photograph are distracting, and draw the viewer's eye away from the subject.

Answer

8. True

● Section Self-Test #1

Use a separate sheet of paper to write down your responses to the following questions. Check your responses against the answers provided in appendix A.

1. What three basic elements determine if a photograph is technically perfect?
2. What three basic requirements determine if a photograph is aesthetically pleasing?
3. *True or False.* Of all the many criteria and characteristics listed in this book, most should be found in marketable photographs.
4. Overexposure, saturated color, and sharp focus are characteristics of:
 a. Exposure
 b. Impact value
 c. Subject emphasis
5. *True or False.* The difference between visual impact and emotional impact is that visual impact has "grabbing" power, and emotional impact attracts viewers.
6. *True or False.* The difference between a theme and a universal theme is that a theme can be any idea or concept, but a universal theme must be recognized by people everywhere.
7. *True or False.* Three or four subject-emphasis characteristics in a photograph are overkill; outstanding photographs contain only one or two subject-emphasis characteristics.
8. Placement, relative size, and selective focusing are characteristics of:
 a. Exposure
 b. Impact value
 c. Subject emphasis
9. *True or False.* In photograph 5-1, the two police officers on horseback project more information to the viewer about what the Italian police look like than would a single officer.
10. *True or False.* Unnecessary elements in a photograph that are subdued and don't stand out will not distract the viewer's eye from the subject.

● Editing the Photograph

You know that the police officer on the left of the frame, along with the distracting streetlights directly above his head, can be eliminated from the photograph by cropping the image. You draw a vertical crop line down the photograph between the two police officers, as shown in photograph 5-2.

What elements determine if a photograph is technically perfect?

103

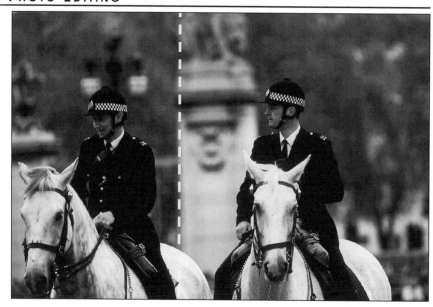

Photograph 5-2—
Cropping out the officer on the
left of the frame

9. True or False.
Cropping is an effective way to eliminate unwanted elements in a photograph.

Answer
9. True

10. True or False.
Cropping should be used sparingly as too much of the original photograph may be eliminated.

Answer
10. False. What is "too much"? Cropping is an effective technique for eliminating all unnecessary elements and clutter from a photograph.

You carefully examine the cropped image. Now the photograph looks a little better, and there is only one subject (there are no longer two subjects competing for attention). But there is still something wrong. You refer to your notes. Ah, yes, it is the placement of the subject. By cropping out the police officer on the left of the frame, you moved the left border of the photograph closer to the subject. The subject in the cropped area of the photograph is now looking out of the photographic frame, and to most viewers—including photo editors—that feels compositionally awkward. You know the basic rule of placement states that if the subject is looking toward the left (viewer's perspective), then the subject should be placed on the right side of the photograph and facing inward toward the center of the frame. How do you move the officer to the right of the frame? Crop away the space on the right side of the subject. In this case, a tight crop will place the police officer near the right border of the frame; you draw a vertical crop line down the photograph adjacent to the right side of the police officer, as shown in photograph 5-3.

Notice that the cropped image is now in portrait (vertical) format. The original image was in landscape (horizontal) format. Recall from lesson 4, "The Perfect Photograph," that vertical formats are more appropriate for portraits (like the police officer on horseback), and horizontal formats are more appropriate for scenics (like cityscapes, seascapes, and landscapes). What have you accomplished so far by editing this photograph? The original image (photograph 5-1) satisfied only two subject emphasis criteria: selective focusing and relative size. The cropped image (photograph 5-3) now satisfies four subject emphasis criteria: selective focusing, relative size (the subject now occupies nearly the entire cropped area of the new frame), placement (the subject is looking inward toward the center of the frame),

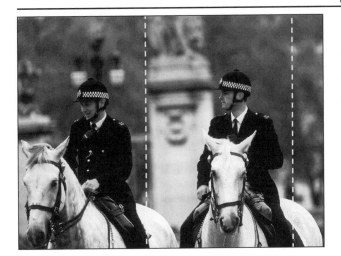

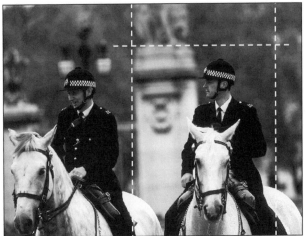

and geometric form (the three points of a triangle are located at the subject's head, left knee, and right knee). In addition, the principle of thirds is now being applied more effectively. The police officer and the body of the horse are aligned along the right vertical one-third grid line in the photographic frame, the police officer's head and shoulders are aligned along the upper horizontal one-third grid line (and at or near the upper right balance point), and the horse's head is aligned along the lower horizontal one-third grid line.

Photograph 5-3—Cropping out space on the right side of the frame (above left)

Photograph 5-4—Cropping out the empty space at the top of the frame (above right)

You carefully examine the cropped photograph and decide that one more crop is needed to complete the image. The subject appears to be a bit too low in the newly cropped area, so you eliminate some of the space at the top of the photograph by drawing a horizontal crop line across the photograph and slightly above the subject's head as shown in photograph 5-4. By cropping out the dead space above the subject's head, you have accomplished two things: you have eliminated unused or empty space in the photograph, and you are filling more of the photographic frame with the main subject (optimizing subject emphasis by increasing relative size).

You compare the cropped image to the original photograph and immediately see a significant improvement. Now that you have increased the visual impact of the image through cropping, all that is left to do is have a new print made from the cropped image.

12. Cropping can change the orientation of an image from a _____ format to a _____ format.

13. **True or False.** A photograph that has been effectively cropped can end up with more compositional characteristics than it originally had.

Answers

12. landscape, portrait (or portrait, landscape)

13. True. Compare photographs 5-1 and 5-3.

● Section Self-Test #2

Use a separate sheet of paper to write down your responses to the following questions. Check your responses against the answers provided in appendix A.

1. *True or False.* Relative size and placement of the subject in an image can be easily controlled through cropping.
2. *True or False.* It is not good to crop out too many areas of a photograph.
3. *True or False.* The orientation of a photograph from landscape format to portrait format, and vice versa, can be changed through cropping.
4. *True or False.* Cropping is an effective way to eliminate unwanted elements in a photograph.
5. *True or False.* Cropping can also be used to eliminate empty or dead space in a photograph.
6. *True or False.* A properly cropped photo can end up with fewer compositional characteristics than it originally had.

● Maintaining Aspect Ratio

Aspect ratio is maintained within an image when the photo's proportions within the photographic frame remain intact as the print's dimensions change. If the cropped image of a subject is enlarged, the subject will be enlarged in direct proportion to the increased frame size; if the image of a subject is reduced, the subject will be reduced in direct proportion to the decreased frame size.

Photo editors will often "size" a photograph to fit a page column or oddly shaped area, and this often results in the loss of aspect ratio. To maintain aspect ratio, enlargement or reduction requests are given to the darkroom technician (or photo lab) in percentages.

When using percentages to enlarge or reduce images, always instruct the darkroom technician to enlarge *to* or reduce *to* a specific percentage. Do not instruct the technician to enlarge *by* or reduce *by* a specific percentage. There is good reason for this rule: If you reduce a 10" line *to* 60%, the line will be reduced to 6". If you reduce a 10" line *by* 60%, the line will be reduced to 4". Do you see the difference?

Suppose a 4" x 6" image in portrait format has to be reduced to fit into a 2" wide column in a magazine, and aspect ratio must be maintained. How would this be accomplished? The width dimension of the original image is divided into the width dimension of the magazine column. (Use a basic calculator to perform the division or simply work out the math on a piece of paper.) 2 ÷ 4 = 0.5 or 50%. (To convert a decimal number to a percentage, start to the left of the

number and move the decimal point two places to the right; replace the decimal point with a percent sign.) To fit the 4" x 6" image in portrait format into a 2" wide column, the darkroom technician would be instructed to reduce the image *to* 50%.

Understand that when the darkroom technician reduces the image to 50%, both the height and length dimension of the image will be reduced to the same percentage value. Therefore, the new dimensions of the 4" x 6" image will be 2" x 3" (aspect ratio has been maintained).

A photo editor must determine which of the photo's dimensions —the width or length—is the most important dimension to enlarge or reduce, and then use that dimension for publication purposes. For example, let's say the column space into which a photo editor wants to place the 4" x 6" image in portrait format is only 2" wide. The primary concern is with the width dimension. Suppose the photo editor wants to place a 4" x 6" image in landscape format into a double column or a column 4" wide. By dividing the 6" width of the image into the 4" width of the column, the reduction percentage becomes 67% (4 ÷ 6 = 0.666 or 67%). To fit the 4" x 6" image in landscape format into a 4" wide column, the photo editor would instruct the darkroom technician to reduce the image *to* 67%. The new dimensions of the 4" x 6" image will be 2.7" x 4". Aspect ratio has been maintained.

Now, suppose the photo editor wants to fit the 4" x 6" image in portrait format into a space that measures 3.5" wide and 5" high (why are you cringing?). The solution is simple. Just follow the same basic procedure. The maximum width of the allotted space is 3.5". The width of the photograph is 4". 3.5 ÷ 4 = 0.875 or 87.5%. To fit the 4" x 6" image in portrait format into a 3.5" wide space, the photo editor would instruct the darkroom technician to reduce the image *to* 87.5%.

Have you noticed a little mathematical trick in all these calculations? To reduce an image, you must divide the larger value into the smaller value. To reduce a 4" x 6" image in portrait format to fit into a 2" wide column, we divided the 4" width of the image into the 2" width of the column. What do you think you must do to enlarge an image? Simply reverse the procedure. That is, divide the smaller value into the larger value. For example, to enlarge a 4" x 6" image in portrait format to fit into a 5" wide space, simply divide the 4" width of the image into the 5" width of the space. 5 ÷ 4 = 1.25 or 125%. To fit the 4" x 6" image in portrait format into a 5" wide space, a photo editor would instruct the darkroom technician to enlarge the image *to* 125%.

14. **True or False.**
 When using percentages to enlarge or reduce images, always instruct the darkroom technician to enlarge by or reduce by a specific percentage.

15. To convert a decimal number to a percentage, move the decimal point _____ places to the _____ of the number.

Answers

14. False. Instruct the technician to enlarge to or reduce to a specific percentage.

15. two, right

16. Before enlarging or reducing a photograph for publication, a photo editor must first determine which _____ is more important.

Answer

16. dimension

17. To reduce an image by a specific percentage, you must divide the _____ value into the _____ value.

18. To enlarge an image by a specific percentage, you must divide the _____ value into the _____ value.

Answers

17. larger, smaller

18. smaller, larger

That's all there is to maintaining aspect ratio. Of course, if maintaining aspect ratio is not important, then just enlarge or reduce the image to your satisfaction.

The easiest way to reduce or enlarge an image while maintaining aspect ratio is to use a proportion wheel. A proportion wheel is a device that allows you to quickly determine reduction and enlargement values (in percentages) while maintaining aspect ratio. It is usually available in the form of a simple cardboard or plastic dial. Proportion wheels can be purchased in most art supply and camera stores.

Examples of Aspect Ratio and Image Distortion. Photograph 5-5 is an original photograph of Wayshee Zhang, academic administrator for International Photo College. The image is 2" high and 1.5" wide.

Photograph 5-6 represents the same image, enlarged to 133%. By enlarging the image by a determined percentage, both the height and width dimensions are increased proportionately and aspect ratio is maintained.

In photograph 5-7, however, only the width dimension has been increased and the image is width-distorted (aspect ratio has not been maintained). The height of the image remained at 2", while the width of the image increased from 1.5" to 1.75". Likewise, only the height dimension of photograph 5-8 has been increased and the image is height-distorted (aspect ratio has not been maintained). The width of the image remained at 1.5" while the height of the image increased to 2.5".

Photographs 5-7 and 5-8 are excellent examples of how images can be distorted if aspect ratio is not maintained. In these examples, viewers would immediately detect the distortion of the image or at the very least feel that something was wrong with the photograph.

Must aspect ratio always be maintained when reducing or enlarging photographs? As photographs 5-9 and 5-10 of the roses demonstrate, some images are not visually affected if aspect ratio is not maintained. Both photographs of the roses are acceptable images and, if displayed separately, the viewer would not feel any sense of distortion from the image in photograph 5-10. Use your hand to cover one photo and view the other, and vice versa. Both images work equally well. As a photographer who edits your own images, you must decide when maintaining aspect ratio is required, and when it isn't necessary. Generally, maintaining aspect ratio is a must when enlarging and reducing images of people. For animals, flowers, and most inanimate objects, use common sense.

So why should you, as a photographer, know about aspect ratio and calculating reduction and enlargement percentages? First, it gives

Photograph 5-5—
Original photo

Photograph 5-7—
Width-distorted
photo

Photograph 5-6—
Enlarged to 133%

Photograph 5-8—
Height-distorted photo

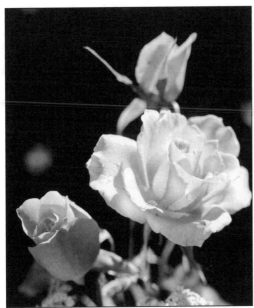

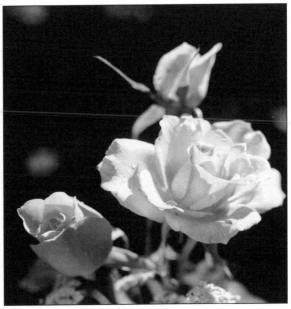

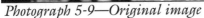

Photograph 5-9—Original image

Photograph 5-10—Distorted image

19. **True or False.**
Height or width distortion is usually not acceptable for images of people and can be easily detected by the eye.

20. Distortion in photographic images is the result of not maintaining _____ _____.

21. **True or False.**
In most cases, maintaining aspect ratio in photographs of inanimate objects is not required.

Answers
19. True
20. aspect ratio
21. True

you an understanding of why some images, especially images of people, are distorted when only the height or width dimension of the picture is reduced or enlarged. Second, it enhances your status as a competent photographer, which improves your professional relationships with photo editors, art directors, and other graphics-oriented people (they appreciate that they are dealing with someone who understands their needs).

22. **True or False.** Photographers really have no need for knowing about aspect ratio and calculating reduction and enlargement percentages, because these are the concerns of photo editors.

Answer
22. False. Graphics-oriented people usually appreciate dealing with someone who understands their needs.

Suppose an editor asks you to reduce the height dimension of a 4" x 5" photograph of an artist in portrait format to 4" to fit the height of a magazine column. You know that in order to maintain aspect ratio, you can't reduce the height dimension of the photo without reducing the width dimension. You do the math (4" ÷ 5" height of photo = 0.8 or 80% and 80% of the 4" width of the photo = 3.2") and you say, "The height dimension will have to be reduced to 80%. That means the width dimension will be reduced to 3.2 inches to maintain aspect ratio. Is that okay?" The editor replies, "Oh, wait! The width of the column I'm dropping the photo into is only 2.75"." The editor realizes the photo will have to be reduced a little more to fit the width of the magazine column. He's impressed with your knowledge of aspect ratio and your ability to work with reduction and enlargement percentages. You can bet that this editor will deal with you again in the future.

23. **True or False.** A photographer who knows how to maintain aspect ratio may be perceived as more of an asset to photo editors and graphics people.

Answer
23. True

Let's return to the cropped image of the Italian police officer on horseback (photograph 5-4). Suppose the height and width dimensions of the photograph are 2.75" and 4" respectively, but the height of the cropped dimension is 2.25" and the width of the cropped

dimension is 1.75". Let's see what happens when we enlarge only the height of the cropped area by 2" (the new height becomes 4.25" and the width remains 1.75"). The result is illustrated in photograph 5-11. The image has now become height-distorted. Now, let's enlarge only the width of the cropped image area by 1" (the height remains 2.25" and the new width becomes 2.75"). The result is illustrated in photograph 5-12. The image has been width-distorted.

Photograph 5-11—Height-distorted image of Italian police officer on horseback (left)

Photograph 5-12—Width-distorted image (above)

Now, let's see what happens when we enlarge the height of the image by 2" while maintaining aspect ratio. Recall from the section on maintaining aspect ratio that when you enlarge an image you must divide the smaller value into the larger value. If you enlarge the height of the cropped image by 2", the new height dimension becomes 4.75" (2.75" + 2" = 4.75"). Therefore, you must divide the new height dimension of 4.75" by the original height dimension of the cropped image (4.75 ÷ 2.25 = 2.11). Convert 2.11 to a percentage by moving the decimal point two places to the right (2.11 = 211%). Remember, we're going to enlarge the cropped image by 211% and not by linear inches. Instruct the darkroom technician to enlarge the height of the image *to* 211%. The result is illustrated in photograph 5-13. We could have chosen to enlarge the width of the image and still maintain aspect ratio. Divide the new width dimension (1.75" + 1" = 2.75") by 1.75", the original

. . .you must divide the smaller value into the larger value.

111

width dimension of the cropped image (2.75 ÷ 1.75 = 1.57). Convert 1.57 to a percentage by moving the decimal point two places to the right (1.57 = 157%). Instruct the darkroom technician to enlarge the width of the image *to* 157%. The result is illustrated in photograph 5-14. Aspect ratio has been maintained in both images.

Photograph 5-13—Aspect ratio maintained
(no height-distortion)

Photograph 5-14—
Aspect ratio maintained
(no width-distortion)

Photographs 5-13 and 5-14 are the finished images that were cropped and enlarged from photograph 5-4. Compare them to photograph 5-4. The officer and the horse occupy the same amount of area in each of the three photographic frames. Aspect ratio has been maintained in each image. Stated differently, the image of the officer and the horse, with respect to each of the photographic frames, is proportionately equal. The only thing that has changed is the size of the image area. This is what maintaining aspect ratio is all about.

Important: If you wish to reduce or enlarge an image to a specific height or width dimension, you must choose the dimension that is important to you and reduce or enlarge the image using only that dimension. For example, the cropped height dimension of photograph 5-4 (2.25") was increased by two additional inches, or enlarged to 211%, increasing the height to 4.75". The cropped width dimension (1.75") was automatically increased to 3.7" (maintaining aspect ratio). To enlarge the cropped width dimension of photograph

5-4 (1.75″) by 1″ to an overall width of 2.75″, the width dimension was enlarged by 157%. The cropped height dimension was automatically increased to 3.53″ (maintaining aspect ratio).

● Section Self-Test #3

Use a separate sheet of paper to write down your responses to the following questions. Check your responses against the answers provided in appendix A.

1. Maintaining the same image proportion with respect to the photographic frame when reducing or enlarging a photograph is known as:
 a. Percentage
 b. Aspect ratio
 c. Relative size

2. When using percentage to enlarge images, always instruct the darkroom technician to:
 a. Enlarge the image by a specific percentage
 b. Enlarge the image to a specific percentage
 c. Enlarge the image by either the height or the width dimension

3. To convert a decimal number to a percentage, move the decimal point:
 a. Two places to the left
 b. Two places to the right
 c. Two places to the right and replace the decimal point with a percentage sign

4. What is the first thing a photo editor must determine before reducing or enlarging a photograph for publication?
 a. Which dimension (height or width) is more important
 b. By what percentage the height of the photograph should be reduced or enlarged
 c. By what percentage the width of the photograph should be reduced or enlarged

5. To reduce a photograph by a specific percentage, you must:
 a. Divide the original dimension of the photo into the smaller reduction dimension
 b. Divide the smaller reduction dimension into the original dimension of the photo

6. To enlarge a photograph by a specific percentage, you must:
 a. Divide the original dimension of the photo into the smaller reduction dimension
 b. Divide the smaller reduction dimension into the original dimension of the photo

To reduce a photograph by a specific percentage, you must. . .

7. *True or False.* A certain degree of height or width distortion is acceptable for images of people.

8. *True or False.* Maintaining aspect ratio in photographs of inanimate objects is always required.

9. *True or False.* Photographers who market their photographs do not need to know about aspect ratio or calculating reduction and enlargement percentages.

10. *True or False.* A photographer who knows how to maintain aspect ratio may be perceived as more of an asset to photo editors and graphics people.

● Targeting the Correct Market

The editing process also includes targeting the market that will be most receptive to your photographic images. Trying to market images of domestic farm horses to a wildlife magazine would be a fruitless waste of your valuable time and energy. No matter how breathtakingly beautiful your horse photographs may be, the photo editor of a magazine that deals with wildlife images is not going to publish pictures of domestic farm animals. On the other hand, pictures of wild horses in their natural environment might find extreme favor in the eyes of a wildlife publisher.

Too many photographers make the same mistake—they think a magazine devoted to animals will publish all kinds of animal photographs, or a magazine devoted to automobiles will publish all kinds of automobile photographs. These photographers are thinking in general terms instead of targeting their audience. A magazine that is devoted to winged animals, such as flying and nonflying birds, will not publish photographs of nonwinged animals, such as cats, dogs, or elephants. A magazine that is devoted to classic automobiles, like a 1929 Rolls Royce, will not publish photographs of contemporary automobiles, like the current editions by Chevrolet or Ford.

> **24. True or False.**
> A photograph of the cockpit of a commercial airliner would be an appropriate image to market to a private pilot magazine.
>
> *Answer*
> 24. False. Most private pilot magazines are devoted to small single-engine aircraft.

> **25. True or False.** *Outdoor Photographer* magazine might be interested in publishing a still life image of butterflies and flowers shot on a tabletop in a studio.
>
> *Answer*
> 25. False

One of the best and easiest ways to target your audience is to research the magazines that publish the kinds of photographs you wish to market. If you have a large collection of flower shots, look through garden and horticulture magazines; if you have a collection of wildlife shots, sort out the images according to different categories

like birds, mammals, and reptiles. Research publications that cater to these specific categories. Visual research is an important tool that many photographers overlook. A wonderful resource to use in researching photo buyers for specific types of images is *Photographer's Market*, an annual directory that lists thousands of places to sell your photographs. Refer to appendix B for a list of marketing resources.

26. **True or False.** Visual research is an important tool that many photographers overlook.
27. An excellent resource publication for researching photo buyers is _____ _____.

Answers
26. True
27. *Photographer's Market*

Use common sense! Targeting your audience is not rocket science. Just match the needs of the photo buyer to the kinds of images he or she wants. The same is true of magazine publishers, poster and photo art publishers, advertising and design firms, stock photo agencies, book publishers, the travel industry, and other photo marketing businesses. Recall the two images of the train in lesson 1, "The Art of Editing Photographs." The lesson began with a question: Which of the photographs of the train is the better image? The answer was that it depends on what the photograph is being used for. That question and answer brought us to the very first rule of successful photo editing: Select and edit your images for your target audience.

● Criteria for Editing and Selecting Marketable Photographs

Now you must determine if you've accomplished your ultimate goal: Have you succeeded in transforming a good photograph into an outstanding photograph? In this last section of this lesson, five important criteria for editing and selecting outstanding photographs are presented. If you can answer yes to these five questions then, chances are, the photograph you're evaluating is an outstanding photograph.

Is the Photograph Properly Exposed? This is a major complaint of photo editors on magazine staffs. As unbelievable as it may seem, there are photographers who will submit an improperly exposed photograph to a photo editor and expect to get a positive response. What is a properly exposed photograph? Professional photo editors routinely examine photographic images for absolutely sharp focus, often using a magnification loupe. Every photograph that you submit for publication should be tack sharp, unless you intended the photograph to be a soft-focus image. If the photograph is black and

Visual research is an important tool that many photographers overlook.

115

white, the image should demonstrate a good range of gray tones. High-contrast black and white images will have fewer gray tones than low-contrast black and white images, but even high-contrast black and white images should have several tones of gray in them, including pure white and pure black.

Always examine the highlights (bright areas) and shadows (dark areas) in black and white and color photographs for detail. In some photographs, the highlights—a bright sky, a snow-covered field, a white sandy beach on a sunny day—are completely burned out and appear as pure white areas in the print. Shadow areas sometimes go completely black. Unless a totally black area is intentionally included in the photograph for impact or compositional value (such as human silhouettes against a sunset), or a totally white area is deliberately being utilized to attract the viewer's eye (such as the bright twinkles of sunlight shining through the leaves of a tree), important shadow and highlight areas should contain some detail.

Color photographs should be examined for color saturation. Make it a habit to scrutinize color images for correct color balance and fidelity. Are reds really red, or have they taken on a pink color? Are blues really blue, or have they taken on a purple or violet color? And if there are various shades of red or blue or green in the original scene, have they been accurately reproduced, or do they appear as one color—with no separation of shades—in the photograph?

Does the Photograph Have Impact Value? This is another major complaint of photo editors, and it ranks right up there with proper exposure. Of the thousands of photographic submissions evaluated by photo editors every year, only about 10–15% have real impact. Impact is grabbing power! It makes you stop and look at the photograph. It plays on your emotions. It produces a definite response. Does the photograph make you smile? Does it make you wrinkle your brow? Does it evoke a feeling? Photo editors want images that make powerful statements.

Photo editors can easily tell if a photograph has impact value by the way people react to it. The response can be positive or negative, but it can't be one of indifference. If you look at a photograph, and you're not moved by it—you don't feel some kind of emotional tug—then the photograph lacks impact. If you feel an emotional tug, display the image to others and observe their reactions. In fact, it's a good idea to show the photograph to at least a half dozen people before you make a final determination on the impact value of the image. If the image has real impact power, most people will respond to it emotionally, even if they don't understand why.

Sometimes, at first glance, a photograph may seem to lack impact value. However, closer scrutiny may reveal that if the photograph was

Photo editors want images that make powerful statements.

cropped a certain way, the impact of the image might be greatly improved. For example, a photograph of a wolf off in the distance might not seem very interesting or dramatic, but after cropping the image to eliminate all the empty space around him and then enlarging the image, the wolf may suddenly appear more threatening.

Is the Theme or Subject Easily Identifiable? Quite frankly, photo editors want to see a story in every photograph; they want to see a clearly identifiable theme and subject. A good photograph communicates a message to the viewer and contains a universal theme. As you learned earlier, a universal theme is meaningful to people everywhere. It is the hallmark of an exceptional photograph. It grabs the viewer's attention and tugs at the viewer's emotions.

Has the Theme or Subject Been Successfully Emphasized? A good photograph emphasizes the theme or subject by focusing attention to it. Sometimes you can focus attention to a subject by simply cropping everything else out of the frame and enlarging the subject. Photo editors often complain that they sometimes receive photographs with wonderful universal themes, but the photographer failed to reinforce the theme by effectively focusing attention to it. A theme is an idea or concept that cannot be graphically fixed on film. It must be conveyed to the viewer through other elements in the photograph.

Have the Nonessential and Distracting Elements Been Eliminated? A good photograph contains only those elements that are essential for successfully emphasizing the subject and the theme within an image. All other elements that are not essential to—or distract from—the photograph should be eliminated. Cropping is an effective tool for simplifying images. Too often, photo editors receive good photographs they can't use. The images are properly exposed and sharply focused, they have impact value, and they contain an easily identifiable subject or theme. The photographer included all the elements of a successful photograph, but failed to simplify the image.

● Section Self-Test #4

Use a separate sheet of paper to write down your responses to the following questions. Check your responses against the answers provided in appendix A.

1. *True or False.* The best market for photographic images of ski boats with powerful outboard engines is *Yachting World* magazine.
2. *True or False. Sail* magazine might publish photos of a sailboat racing event that took place off the southern coast of California.

> **Photo editors want to see a story in every photograph.**

Congratulations! You have now completed all the lessons in this book.

3. A simple and effective tool that many photographers often overlook for marketing their images is:
 a. Querying publishers about what they want to see
 b. Visual research in magazines that publish similar images
 c. Contracting with stock photo agencies.

4. *True or False. Photographer's Market* is an excellent resource publication for researching photo buyers.

5. *True or False.* Improperly exposed images is a major complaint of photo editors on magazine staffs.

6. Photo editors also frequently complain about:
 a. The submission of images that have no visual impact
 b. Subjects that are not easily identified in photographs
 c. Themes that are not easily identified in photographs

7. *True or False.* All subjects and themes in photographs should be easily identified.

8. *True or False.* Emphasis of the subject or theme is not important as long as the subject or theme is easily identified.

9. *True or False.* If the subject of the photograph is forcibly emphasized through selective focusing, and the rest of the image is out of focus, nonessential or distracting elements need not be eliminated from the image.

10. *True or False.* Editing photographic images is much like editing manuscripts for publication; you always look for ways to improve the overall presentation of your work.

● Lesson Summary

Congratulations! You have completed all the lessons in this book. You should have a thorough understanding of the following concepts, and should know how to apply them to photographs for the purpose of selecting and evaluating images for publication:

- Technically perfect photographs
- Aesthetically pleasing photographs
- Exposure characteristics
- Impact-value characteristics
- Identification characteristics
- Subject-emphasis characteristics
- Distraction characteristics
- Improving compositional characteristics through cropping
- Maintaining aspect ratio
- Targeting the correct market
- Criteria for editing and selecting marketable photographs

APPENDIX A
Answers to Self-Test Questions

Answers to the questions for lessons 2 through 5 are provided in this appendix. Answers are listed by lesson number and section self-test number.

● Lesson 2: "Patterns Balance and Order"
Section Self-Test #1

1. 5" x 8" (exactly 5:8 ratio) and 10" x 16" (2 x 5:8 ratio)

2. Yes. A rectangle whose sides are 10 squares wide in one direction and 16 squares wide in the other direction maintains the exact same ratio as a rectangle whose sides are 5 squares in one direction and 8 squares in the other direction (2 x 5:8 = 10:16). The large increase in total number of squares from 40 to 160 is a result of increased area. In maintaining a 5:8 ratio (the ratio of a Golden Rectangle), we are concerned with linear measurement (the length of the sides of the rectangle), not area.

3. False. The 35mm frame is slightly larger.

4. False. The brain still recognizes orderly patterns such as rectangles, circles, triangles, curves, lines, etc.

5. True

6. True

7. True

8. landscape, portrait

9. False. It does reflect the natural world.

10. 8" x 12" and 11" x 16" (these are 35mm full-frame print sizes and correspond to the 2:3 or 0.66 ratio of 35mm negatives).

Section Self-Test #2

1. Establishing balance and order within a photographic frame.

2. True

3. Four

4. False. The principle of thirds is only a tool, not a hard-and-fast rule. Many outstanding photos do not conform to the principle of thirds.

5. False

Note: For answers 6 through 10, refer to photo 2-4, *Kitten Asleep in a Log*.

6. The subject of the photograph is the kitten.

7. The kitten's head and paws have been positioned along the left vertical one-third line, and its body is positioned along the lower horizontal one-third line.

8. The log is a secondary element within the frame.

9. Adds to the image. Most of the image of the log runs along the left and bottom borders of the frame formed by the Golden Rectangle, and the log forms a frame around the subject.

10. Yes. The main elements within this photo are located at or near the points of intersection along the horizontal and vertical one-third lines. The kitten's head is at or near the upper left balance point, its front right paws are at or near the lower left balance point, and its rear left paw is at or near the lower right balance point.

Section Self-Test #3

1. Attracting the viewer's attention to the subject within the photographic frame through the use of various compositional techniques.

2. Placing the subject at a specific position within the photographic frame to achieve balance.

3. Emphasizing the subject by placing it closer to the lens of the camera, making the subject seem larger than it really is.

4. The technique used by photographers to accent a subject through other elements in the photograph.

5. A compositional technique for focusing attention to a distant subject or object.

6. Throwing everything out of focus in the photographic frame except for the subject.

7. Repeated images that are found within the same photographic frame.

8. Emphasizing the subject by giving it a feeling of motion.

9. Creating a powerful three-dimensional effect where the viewer sees something happening in the foreground, middle ground, and background within the photographic frame.

10. Geometric forms like converging lines and imaginary triangles that can dramatically improve photographic composition.

Section Self-Test #4

1. True
2. True
3. True
4. The photographer positioned the taller rose at or near the upper right balance point, the larger rose at or near the lower right balance point, and the smaller rose at or near the lower left balance point, thereby creating both balance and a geometric form within the photographic frame.
5. The way the roses seem to be stretching upward as if they are delighted to be receiving the life-sustaining rays of the sun.
6. The subject's head is positioned at or near the upper right balance point of the photographic frame and its open mouth is positioned at or near the lower right balance point.

● Lesson 3: "Colors, Tones, and Exposure"

Section Self-Test #1

1. Saturation, balance, fidelity, and contrast
2. The intensity of the colors in the photograph
3. Both accurate color reproduction and color cast
4. The faithful color reproduction of the original scene or subject
5. The distinguishable differences between the lightest and darkest shades of the same color
6. Shades of the same color in high-contrast photographs are clearly distinguishable and shades of the same color in low-contrast photographs are nearly indistinguishable.

Section Self-Test #2

1. True
2. True
3. False. Silver-halide crystals are converted into black metallic silver.
4. True
5. True
6. all
7. black
8. some
9. gray
10. none
11. clear
12. The film was exposed to bright light and the silver-halide crystals were converted into black metallic silver during the development process.
13. The film was never exposed and the silver-halide crystals, having received no light, were not converted into black metallic silver. During the development process, all the unaffected silver-halide crystals were washed away.

Section Self-Test #3

1. Silver-halide crystals
2. The red wavelengths are reflected off the rose

3. Red-, blue-, and green-sensitive nerve systems

4. Red- and blue-sensitive nerve systems

5. Red, blue, and green

6. Green- and blue-sensitive film layers

7. Color couplers

8. Cyan, magenta, and yellow

9. Correcting inaccurate color reproductions

10. De-emphasize yellow and magenta or increase cyan

Section Self-Test #4

1. True

2. Aperture

3. larger, smaller

4. doubles, halves

5. Two, four times as much light. From f/8 to f/4 is a total of two full f/stops (f/8 to f/5.6 = 1 f/stop, and f/5.6 to f/4 = one f/stop, for a total of two f/stops) and the aperture is being opened. For each full f/stop the aperture is opened, twice as much light enters the lens of the camera, or twice the light times twice the light equals four times as much light (2 x 2 = 4).

6. Three, $\frac{1}{8}$ as much light. From f/4 to f/11 is a total of three full f/stops (f/4 to f/5.6 = one f/stop, f/5.6 to f/8 = one f/stop, and f/8 to f/11 = one f/stop, for a total of three f/stops) and the aperture is being closed ("stopped down"). For each full f/stop the aperture is closed, half as much light enters the lens of the camera, or one-half the light times one-half the light times one-half the light equals $\frac{1}{8}$ as much light ($\frac{1}{2} \times \frac{1}{2} \times \frac{1}{2} = \frac{1}{8}$).

7. Photograph 3-4, exposed at f/8. If you didn't choose photograph 3-4, don't worry about it. If you chose photograph 3-3, you were close enough—for now! After studying the section on the Zone System, you will fully understand and appreciate why photograph 3-4 is the properly exposed photograph.

8. Follow instructions based upon your answer. Be sure you understand the concept of exposure control before continuing on to the section on the Zone System.

Section Self-Test #5

1. True

2. False. The photographer can control the amount of exposure that each frame of film receives in the camera, but the entire roll of film is subjected to the same development. In other words, the Zone System can be applied to each frame of film as the film is exposed one frame at a time in the camera. The Zone System cannot be applied to each frame of film during development because the entire roll of film is developed at the same time.

3. False. The exposure meter will give the photographer an averaged exposure reading of all the light in the scene.

4. Eleven, pure black, pure white

5. Five, middle gray

6. One, less (exposure meters are calibrated to Zone 5, therefore Zone 4 is one zone less—or one f/stop less—than Zone 5)

7. Three, more (exposure meters are calibrated to Zone 5, therefore Zone 8 is three zones more—or three f/stops more—than Zone 5)

8. The photographer should shoot the photograph in Zone 3. The exposure meter yields a value of f/5.6, which is a Zone 5 value. Zone 3 is two zones—or two f/stops—less than Zone 5.

9. f/11

10. Observing the various tones in the scene and imagining how you want these tones to reproduce in the final print.

11. The photographer exposed the image at a Zone 5 exposure (average exposure).

12. The photographer should have exposed the image at a Zone 4 exposure (the recommended exposure for dark-toned skin).

Section Self-Test #6

1. True

2. True

3. True

4. True. Something within the photograph is usu-

ally in sharp focus because the photographer simply failed to focus properly. For example, the main subject may be slightly out of focus, while an object in the background or the foreground is in sharp focus. In a selective focus image, the reverse is true. The subject is in sharp focus, while everything else is out of focus.

5. False. When camera shake occurs, everything in the photograph is fuzzy or out of focus. This is a result of lens movement at the instant the photograph is exposed.

● Lesson 4: "The Perfect Photograph"

Section Self-Test #1

1. Subject or theme
2. Emphasis of the subject or theme
3. Simplification of the subject or theme
4. focused sharply, properly exposed
5. True
6. False. The print will lose detail in shadow areas.
7. False. The print will lose detail in highlighted areas.
8. True
9. True
10. True

Section Self-Test #2

1. Youth, innocence, love, and other abstract concepts
2. A soldier greeting his sweetheart with a tight embrace, a passionate kiss, and his hat falling from his head
3. The universal themes of passion and love are easily recognized in this image.
4. False. A theme is an idea or concept that cannot be physically dealt with, and must be expressed in an abstract way.
5. No! Without the other elements in the photograph—the dirty and tattered dress, the litter on the steps of the stairway, and the graffiti scribbled on the walls of the hallway—there would be no hint of the little girl's environment. The photograph would be nothing

more than a portrait of a child.
6. No! People everywhere recognize a universal theme. The significance of the restored 1957 Thunderbird and the smiling young man may be easily identified in America, where classic automobiles are admired. In cultures where automobiles are rarely seen, the viewer probably would not understand why the young man is so attached to the car.

Section Self-Test #3

1. True
2. Dust particles
3. True
4. Contrasty
5. Develop a print using the Cibachrome process
6. First, make a negative from the transparency, then make a print from the negative.
7. Send the negative to a commercial laboratory
8. Send the negative to a custom processor
9. False. These are services offered by custom processors.
10. True

● Lesson 5: "Editing Photographs for Publication"

Section Self-Test #1

1. Sharp focus, proper exposure, free of physical defects
2. Clearly identified subject or theme, attention focused on subject on theme, simplification of the subject or theme
3. False. Every photograph must be evaluated according to its purpose and its content.
4. Exposure
5. False. Just the opposite is true. Visual impact attracts viewers and emotional impact has "grabbing" power.
6. True
7. False. Application of more subject-emphasis characteristics reinforces attention to the subject. More characteristics amplify reinforcement.
8. Subject emphasis
9. False. In this case, the two officers project no

more information to the viewer about what the Italian police look like than would a single police officer.

10. False. Insignificant and barely observable elements in a photograph, especially bright spots and ghosts of light, can distract the viewer's eye from the subject.

Section Self-Test #2

1. True
2. False. Wherever possible, crop out all nonessential and distracting elements.
3. True
4. True
5. True. Sometimes empty or dead space in a photograph can be just as distracting as bright spots or ghosts of light and other forms of clutter.
6. False. If a photograph is properly cropped, its compositional characteristics should be enhanced; at the very least, positive and reinforcing compositional characteristics should never be eliminated.

Section Self-Test #3

1. Aspect ratio
2. Enlarge the image to a specific percentage
3. Two places to the right and replace the decimal point with a percentage sign.
4. Which dimension (height or width) is more important
5. Divide the original dimension of the photo into the smaller reduction dimension.
6. Divide the smaller reduction dimension into the original dimension of the photo.
7. False. The eye easily detects distortion in images of people.
8. False. Use common sense! Refer to the examples of the roses.
9. False. Photographers who wish to market their photographs should be knowledgeable in aspect ratio and calculating reduction and enlargement percentages.
10. True

Section Self-Test #4

1. False. The name of the magazine alone should send up warning flags. Outboard-powered ski boats and luxury yachts are in two entirely different classes.
2. True. The subject of the magazine is sailboats. It would be reasonable to assume that a photograph of a sailboat in almost any capacity might be considered for publication.
3. Visual research in magazines that publish similar images
4. True.
5. True. It is probably the number one complaint of most photo editors!
6. The submission of images that have no visual impact.
7. True! True! True!
8. False. One of the most important criteria for editing and selecting marketable images is to ensure that the subject or theme is emphasized.
9. False. Crop out nonessential or distracting elements whenever possible.
10. True

Resources

● Kodak Color Print Viewing Filter Kit

The Kodak filter kit consists of six filter cards: red, blue, green, cyan, yellow, and magenta, with each card containing three gelatin filters of various intensities of the same color. The kit can be purchased through local camera stores or directly from Kodak. (Eastman Kodak Company, 343 State Street, Rochester, New York 14653)

● Recommended Books

Photographer's Market

An annual publication that lists thousands of photo buyers who are interested in purchasing images from photographers. Buyers include stock photo agencies, magazines, newspapers, galleries, book publishers, outdoor/wildlife photo markets, travel photo markets and sports photo markets. A valuable resource for the photographer who wishes to successfully market his or her photographic images. *Photographer's Market* is available from: (Writer's Digest Books, F&W Publications, 1507 Dana Avenue, Cincinnati, Ohio 45207)

Criticizing Photographs: An Introduction to Understanding Images (Third Edition)

For the photo enthusiast who wishes to learn how to criticize photographs. An excellent source for understanding art criticism as it is applied to photography. (Mayfield Publishing Company, 1280 Villa Street, Mountain View, California 94041)

Creating World-Class Photography: How Any Photographer Can Create Technically Flawless Photographs

A beautifully illustrated and informative book on how to shoot outstanding photographs. An excellent source for the photographer who wishes to improve his or her picture-taking capabilities. (Amherst Media, Inc., PO Box 586, Buffalo, New York 14226)

● Helpful Web Sites

The following web sites cater specifically to the amateur and advanced photographer, and offer free courses on how to improve your images:

Kodak Learning Center

http://www.kodak.com/US/en/digital/dlc/
Take a course in digital (electronic) photography. Kodak offers on-line tutorials on digital technology, digital training courses, and digital imaging.

On-line Photo Seminars

http://www.photo-seminars.com/index.htm
Free seminars and articles on a wide range of photography topics are available on this site. Advanced on-line workshops are offered for small fees. Access to free lessons allows the student to sample seminar topics and content before enrolling.

Index